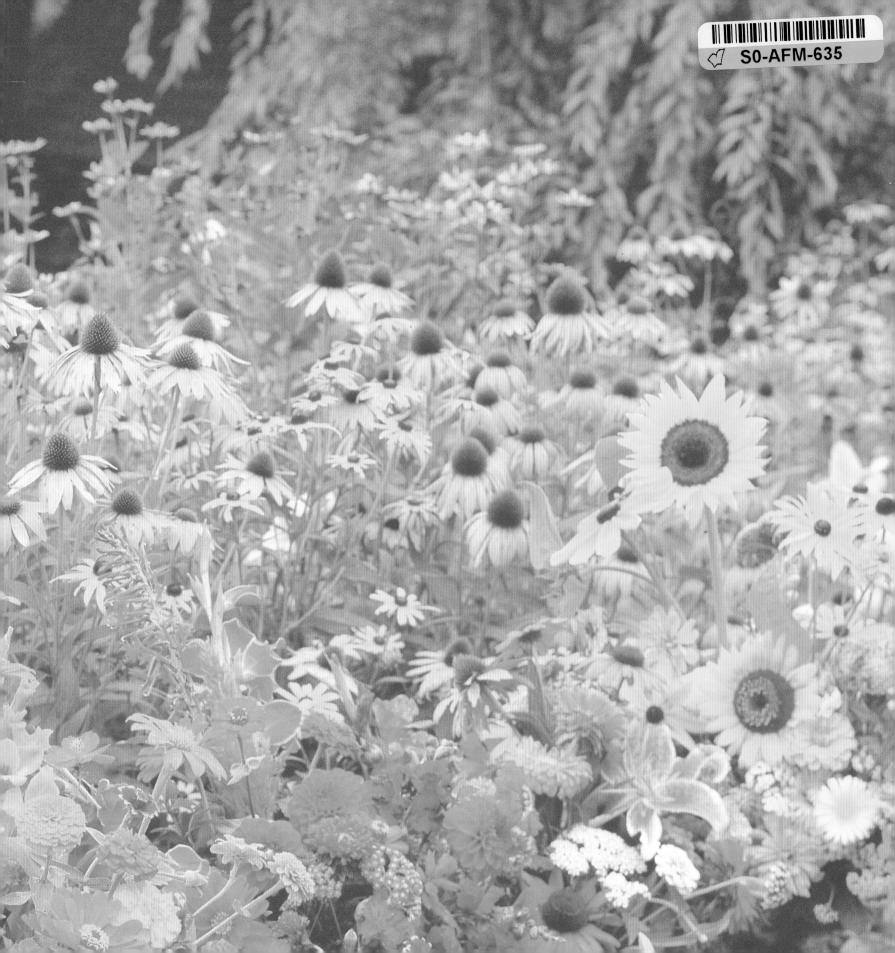

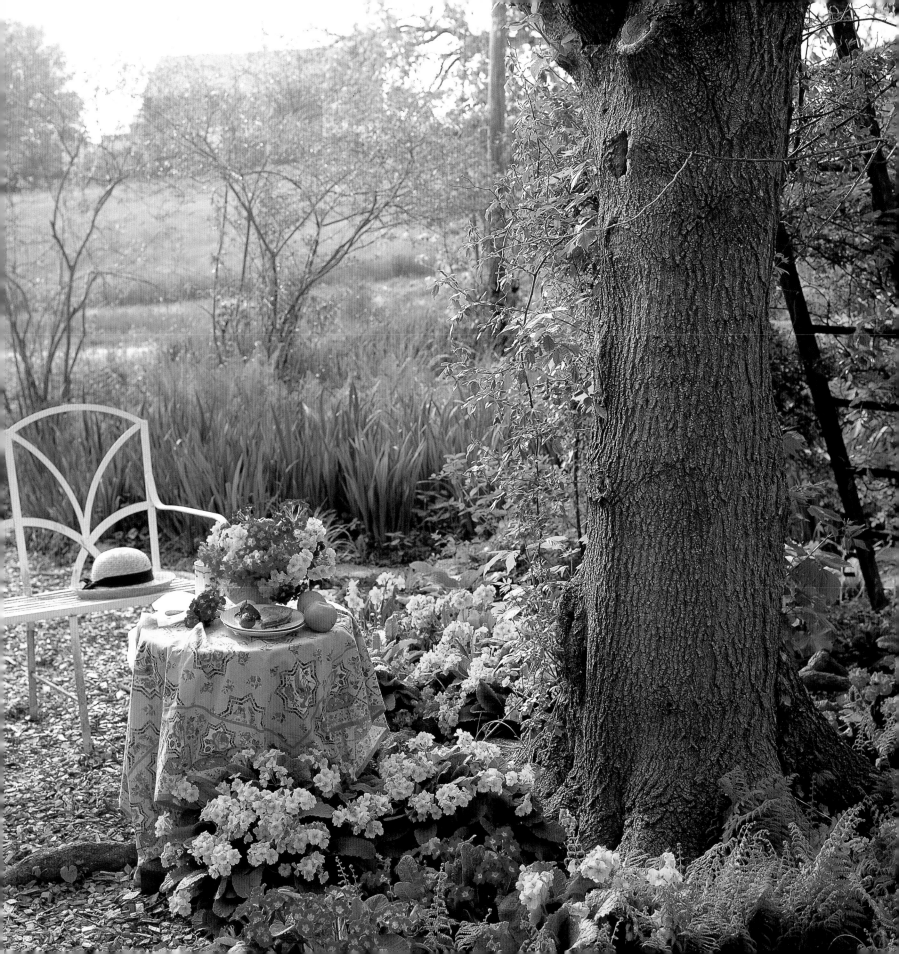

IMPRESSIONIST BOUQUETS

24 Exquisite Arrangements Inspired by the Impressionist Masters

DEREK AND CAROLYN FELL

Photography by Derek Fell

FRIEDMAN/FAIRFAX
PUBLISHERS

A FRIEDMAN/FAIRFAX BOOK

© 1998 by Michael Friedman Publishing Group, Inc.

Library of Congress Cataloging-in-Publication Data available upon request.

ISBN 1-56799-563-2

Editor: Susan Lauzau
Art Director: Jeff Batzli
Designer: Milagros Sensat
Photography Editors: Amy Talluto and Christopher C. Bain
Production Manager: Jeanne E. Hutter

Color separations by HK Scanner Arts Int'l Ltd.
Printed in England by Butler & Tanner Limited

1 3 5 7 9 10 8 6 4 2

For bulk purchases and special sales, please contact:
Friedman/Fairfax Publishers
Attention: Sales Department
15 West 26th Street
New York, New York 10010
212/685-6610 FAX 212/685-1307

Visit our website:
http://www.metrobooks.com

PHOTOGRAPHY CREDITS

All photographs:
©Derek Fell

Paintings:
Amsterdam, Van Gogh Museum (Vincent Van Gogh Foundation): p. 35

Photo ©1997, The Art Institute of Chicago. All Rights Reserved: p. 51

Art Resource: p. 107; ©Giraudon: pp. 87, 91, 95; ©Erich Lessing: pp. 63, 83, 111; ©National Museum of American Art: p. 119; ©Scala: pp. 59, 99

Christie's Images: p. 103

E. T. Archive: Courtesy of the Musee D'Orsay: pp. 67, 123

The Collection of Mr. and Mrs. Derek Fell: p. 55

Courtesy of the Fogg Art Museum, Harvard University Art Museums, Bequest of Grenville L. Winthrop: p. 43

The Hyde Collection, Glen Falls, New York 1971.22: Childe Hassam "Geraniums", 1888, Oil in canvas, 18¼ x 13 inches: pp. 1, 47

Private Collection: "David's Garden" Carol Westcott: p. 31

Courtesy of Westphal Publishing, Irvine, CA: p. 115

Dedication

For our mothers—Anna Kreider and Mary Fell

Acknowledgments

No one has influenced our appreciation of floral arrangements more than garden writer and floral arranger Olive Dunn. When we visited Olive's romantic cottage garden in Invercargill, New Zealand, we discovered her use of the French Impressionist painters as sources of inspiration not only for the arrangements she created for her home but also for the plantings in her small, flower-filled garden. We immediately felt a kinship with Olive and have maintained a steady friendship with her since our meeting in January 1994.

Mrs. Virginia Chisholm, the caretaker of Celia Thaxter's restored garden on rugged Appledore Island, went to extraordinary lengths for us so that we could photograph the garden. She arranged an overnight stay on the beautiful island in dormitories maintained by Cornell University for students of marine biology. Also, at our special request, she grew poppies to photograph in the exact location Celia Thaxter had planted them and Childe Hassam had painted them, along a coastal footpath overlooking the Atlantic Ocean.

We also wish to thank the curators of several museums in France, notably the Renoir Museum at Cagnes-sur-Mer, the Cézanne Museum at Aix-en-Provence, and the Monet Museum at Giverny, for access to the properties at times appropriate for photography.

We owe a special thank-you to Lois Griffel, director of the Cape Cod School of Art, for her enthusiastic support of this project and for her beautiful contemporary Impressionist painting, *Barnhaven Primroses at Cedaridge Farm*, which shows the primrose garden at our home, where many artists find motifs to paint.

Kathy Nelson, our efficient office manager, always holds the fort while we are away on research forays, and Wendy Fields, our grounds supervisor, does a magnificent job of helping to care for our own "Impressionist" garden.

CONTENTS

INTRODUCTION
The Impressionists' Love of Flowers

I mpressionism is a unique style of painting in which flickering brush strokes of color capture the vibrant visual sensations of sunlight and shadow. Named for a painting by Claude Monet (1840–1926) titled *Impression, Sunrise* (1872), the Impressionist style was adopted initially by a group of artists living in France, most of whom cultivated gardens where they sought motifs to paint and in which they grew flowers for beautiful still lifes. When Monet moved to the village of Giverny in 1883, his immediate concern was to plant a flower garden "so as to harvest a few flowers to paint when the weather is bad."

For Pierre-Auguste Renoir (1841–1919), too, his garden at Cagnes-sur-Mer, near Nice, was a special Eden that provided a constant supply of flowers for painting and decorating the house. "I just let my brain rest when I paint flowers," he declared to painter Albert André. "When I am paint-

ing flowers, I establish the tones, I study the values carefully without worrying about losing the picture. I don't dare to do this with a figure for fear of ruining it. The experience which I gain in these works, I eventually apply to my figure paintings."

When Vincent van Gogh moved from Holland to Paris in pursuit of a painting career, he soon came under the spell of Impressionism. To lighten his palette and capture the glowing colors and tonal values of Impressionism, van Gogh went into a frenzy of painting floral still lifes. Realizing that flowers offered the most beautiful range of colors for practicing his technique, he scoured the flower markets of Paris and had friends bring him bouquets from their gardens every week.

In their gardens, most of the Impressionists attempted to create idyllic spaces with design elements borrowed from their art. The gardens of Monet, Renoir, and Paul Cézanne survive to this day, beautifully restored and open to the public.

Other important members of the great Impressionist circle were Gustave Caillebotte, Frédéric Pissarro, Edgar Degas, Edouard Manet, Camille Pissarro, and Alfred Sisley, an Englishman. There were also two women—Mary Cassatt, an American from Pittsburgh, and Berthe Morisot. The painters van Gogh, Cézanne, and Paul Gauguin are considered Post-Impressionists, as their conversion to the Impressionist style came later. Also active in the Impressionist movement were a number of early American Impressionist painters, including Childe Hassam, Lila Cabot Perry, William Robinson, Frederick Frieske, and Willard Metcalf. All journeyed to France and studied Impressionism, helping to spread its popularity farther afield. Today the art of Impressionism is among the most widely acclaimed forms of artistic expression. Impressionist exhibitions still

ABOVE: THIS COLLECTION OF BOUQUETS, ARRANGED IN A RAINBOW OF COLORS, SHOWS THE INFINITE POSSIBILITIES OF DESIGNING IN MONO-CHROMATIC SCHEMES. OPPOSITE: THE IMPRESSIONIST STYLE REMAINS A FAVORITE WITH CONTEMPORARY ARTISTS, AS ILLUSTRATED BY CAROL WESTCOTT'S PAINTING *David's Garden*.

draw record crowds throughout the world, and Impressionist paintings command the highest prices at auction.

Many of the plants the Impressionists used in their arrangements—such as chrysanthemums, dahlias, irises, sunflowers, and poppies—they also grew for their beauty as garden plants. Writing to his wife, Alice, from a painting trip to the Normandy coast, Monet asked, "Are there still flowers in the garden? I hope there will still be chrysanthemums when I get home. If it freezes, make beautiful bouquets of them."

The Impressionists applied to flower arranging many of the lessons learned in the garden and farther afield in the countryside of Provence and Normandy, in particular their liking for certain color harmonies. Among their favorite combinations were red, green, and silver; blue, pink, and white; orange and black; and yellow and blue. These artists also introduced certain structural elements into their floral designs, such as the pleasing contrast of spiky leaves with rounded,

BELOW: LILIES AND COLEUS PRESENT A SIMPLE YELLOW AND GREEN COLOR HARMONY IN MONET'S GARDEN AT GIVERNY. RIGHT: A POPPY FIELD IS RESPLENDENT IN RED, GREEN, AND SILVER, ONE OF THE IMPRESSIONISTS' FAVORITE COLOR COMBINATIONS.

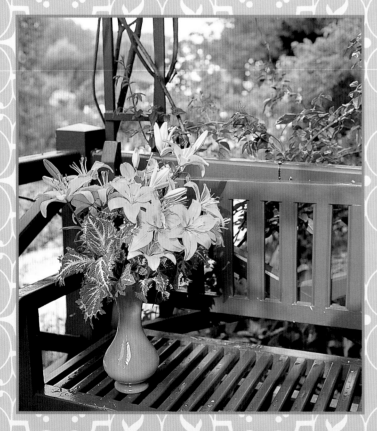

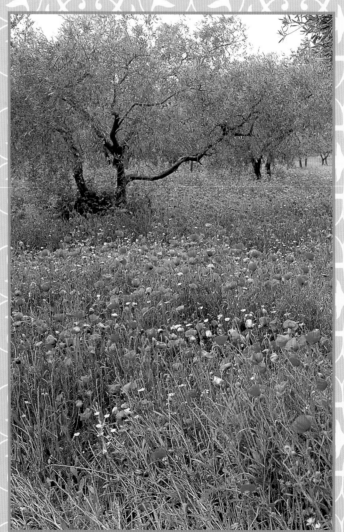

billowing flower heads. Indeed, the Impressionists brought to their floral arrangements elements of design—such as structure, style, form, balance, texture, and rhythm—that were not then taught in any books or schools of floral design.

Vincent's Garden

Once he took to painting, Vincent van Gogh (1853–1890) never settled down to enjoy a home and garden of his own, but he painted many gardens and conducted a stream of affectionate correspondence with his younger sister, Wilhelmina, explaining what he liked about particular gardens and what he changed in his paintings of them to satisfy his aesthetic ideal. He even suggested color harmonies for his sister to try in the family's large rectory garden in Holland, naming the plants he wanted her to use.

VAN GOGH BORROWED MANY OF HIS IRIS MOTIFS FROM THIS GARDEN AT THE ASYLUM AT SAINT-RÉMY IN PROVENCE.

It has been suggested that van Gogh painted flowers because he could rarely afford to pay for models, but it is obvious that van Gogh painted flowers because he loved them passionately. His letters are filled with praise of floral arrangements he admired and painted, and it was his practice capturing brilliant flower colors that aided him in developing the vibrancy for which his later works are noted. Indeed, his paintings of floral still lifes outnumber any other motif, and we know that he not only enjoyed his father's rectory garden in his formative years, but in the spring of 1876, before he developed a passion for painting, he cultivated a small cottage-style flower garden on borrowed land at the rear of an apartment he rented in London, and wrote joyfully about it to his brother: "I have been busily planting a small garden....some seeds of sweet peas, poppies and mignonettes. We shall see what becomes of them."

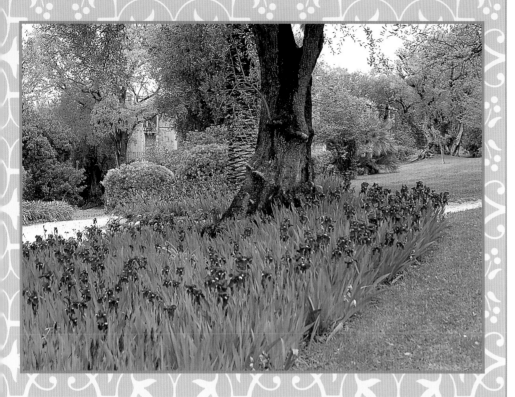

RENOIRS'S GARDEN AT CAGNES-SUR-MER, WHICH OVERLOOKS THE MEDITERRANEAN SEA, FEATURES A SPECTACULAR IRIS BORDER.

Fifteen years later, confined to an asylum at Saint-Rémy, Provence, for treatment of a mental disorder, van Gogh again wrote enthusiastically to his brother: "I am doing a canvas of roses with a light green background and two canvases representing two big bunches of irises, one lot against a pink background in which the effect is soft and harmonious because of the combination of greens, pinks, violets. On the other hand, the other violet bunch (ranging from carmine to pure Prussian blue) stands out against a startling citron background, with other yellow tones in the vase and the stand on which it rests, so it is an effect of tremendously disparate complementaries, which strengthen each other by their juxtaposition."

Renoir's Eden

Even more prolific than van Gogh in his output of floral still lifes was Pierre-Auguste Renoir, an ardent conservationist and close lifelong friend of Monet. Renoir found an ancient olive orchard near Nice, in the south of France, where he liked to paint, and he bought it to save the property from the threat of development. Building a house on a corner of the property for his family and retinue of servants and models, he thought the old trees had near-human characteristics, and he loved to encourage wildflowers to seed under the trees and out into a sunlit meadow below the orchard. He even built a studio with glass walls so that he could paint a particular shadowy vista in all kinds of weather, sometimes with a model seated among sparkling wildflowers.

Renoir liked to start each day with a small vignette before embarking on a more ambitious composition, and this was usually a small bouquet gathered fresh from the garden. Renoir's wife and all his models were skilled flower arrangers, and since the garden was in a mild, frost-free

climate, his floral palette was much more diverse than that of other Impressionist painters and included home-grown anemones, ranunculus, and carnations.

Renoir was decades ahead of his time in appreciating grasses for ornamental effect, restraining his gardeners from mowing his meadow so that the native oat grasses could flower and establish waves of silver and gold as the mistral wind swept over them. There was one part of the property Renoir allowed to be formal—his wife's rose garden, which was located beyond a terrace beneath their bedroom. Renoir especially like to paint arrangements of roses as well as portraits with roses as embellishments, either in bouquets or adorning the dresses and hats of the models he painted. Many of the paintings produced by Renoir have a distinctive rosy glow about them, and it was roses more than any other flower that allowed him to perfect flesh tones, especially in the women and children he loved to paint. At his death, in a bedroom flooded with light overlooking his garden, he had a painting of a bouquet of anemones on his easel, and in his room a beautiful arrangement of roses. His last word before lapsing into unconsciousness was "flowers."

Celia Thaxter's House and Garden

Celia Thaxter (1835–1894) was a lighthouse keeper's daughter who helped her father run a resort hotel that had been built on Appledore Island among the isolated Isles of Shoals, off the coast of Maine. She cultivated a fifteen-by-fifty-foot (4.5 by 15m) cutting garden beyond the front door of her house not only to supply the rooms of the hotel with fresh flowers, but also to decorate her parlor, where she entertained writers and artists.

When Thaxter was inspired to write a book about her garden, American Impressionist painter Childe Hassam (1859–1935) agreed to illustrate An Island Garden with beautiful Impressionist watercolors and pastels. Writing in the book about her flowers, Thaxter said, "Altogether lovely they are out of doors, but I plant and tend them always with the thought of the joy they will be within the house also."

POPPIES GROW FREELY IN THE RESTORED GARDEN OF CELIA THAXTER. HERE CHILDE HASSAM CAME TO PAINT SOME OF HIS BEST-KNOWN WORKS.

Thaxter's parlor ran the length of her house. Large, bright, and spacious, it was intended for listening to piano music. The walls were filled with paintings and bordered by bookcases, and the floors were crowded with comfortable sofas and chairs for lounging. Mantels and tables were always crowded with flowers, particularly her favorites: lilies, poppies, and nasturtiums. "Long chords of color...filled the room with an atmosphere which made it seem like a living rainbow," declared one visitor, Candace Wheeler.

In the cozy parlor, leaders in literature and art gathered to enjoy the

THAXTER'S CUTTING GARDEN, WHICH FURNISHED FRESH BLOOMS FOR THE HOUSE, PERCHES ATOP A CLIFF ON APPLEDORE ISLAND, OFF THE COAST OF MAINE.

company of Celia Thaxter, who presented a handsome Victorian presence and sharp intelligence. "Appledore's brightest attraction was Celia herself, and the cultural salon over which she presided," observed writer Stephen May, while writer C.T. Young described her as "the most beautiful woman I ever saw, not the most splendid nor the most regular in feature, but the most graceful, the most easy, the most complete." Another observer wrote, "As the 'Rose of the Isles,' Thaxter held court on Appledore for over a quarter of a century."

Hassam was born in a suburb of Boston and first met Thaxter when she attended one of his watercolor classes on the mainland. His style of painting is very similar to Claude Monet's, and though he denied any influence from Monet's work, he visited Impressionist exhibitions while studying in Paris and readily converted to Impressionism. In 1894, the year of Thaxter's death, he rendered a view of her parlor in what is considered by many to be his greatest work, *The Room of Flowers* (see page 39), which shows a young woman in a pale pink dress reclining on a comfortable couch while reading. The lady is almost invisible because of the vibrance of the flowers in the room. Most pleasing is the unique color harmony that Hassam painted, a delightful combination of green and gold—green from sunlit leaves showing through the windows and gold from the preponderance

of yellow and gold flower arrangements in the room, including a splashy display of yellow Asiatic lilies in the foreground.

Hassam visited Appledore Island each summer over a period of more than twenty years, even after Thaxter passed away. In addition to an extraordinary number of floral still lifes that are like nothing else in Impressionist painting, Hassam captured the beauty of the garden in delicate pastels that show reds and pinks—from hollyhocks and poppies—almost always against a background of blue water from the northern Atlantic Ocean.

Thaxter's garden and house did not survive long after her death. The garden was neglected and the house burned down with the hotel in 1914. In subsequent years the island was used by the armed forces for target practice, and then became the location for the Shoals Marine Laboratory, run by Cornell University and the University of New Hampshire. In the late 1970s the director of the laboratory restored the garden to its former glory, and today it is maintained by a group of enthusiastic volunteers from the Rye Garden Club.

Hassam became a prominent figure in American art, forming the Group of Ten, a collective of ten great American Impressionist painters from the New England area who organized group exhibitions to promote American Impressionist painting on a par with the French. After his death in 1935, Hassam's will required that more than four hundred paintings from his studio be sold and the money used to acquire American art for presentation to American museums.

Monet's Garden

Monet took a lot of inspiration from his own garden at Giverny, and he shared his liking of certain flowers with Caillebotte, who maintained a one-acre (4,047 sq m) garden with a greenhouse on a property overlooking the Seine River. Caillebotte loved to paint compositions with strong lines of perspective and powerful structural elements. He not only planted his garden in long narrow rows, he filled the beds with tall sunflowers and hollyhocks and the tousled heads of dinnerplate dahlias and football chrysanthemums,

MONET'S GARDEN AT GIVERNY FLOURISHES IN AUTUMN WITH TALL SUNFLOWERS AND BILLOWING ASTERS.

all of which he loved to paint in still life arrangements. Caillebotte built a greenhouse to have fresh flowers year-round and to maintain a collection of orchids. Monet followed his example.

For his garden, Monet took over a plum orchard and first planted his ideal flower garden, filling it with some of his favorite color harmonies—especially white, blue, and pink; silver, red, and green; and yellow and blue—all of which he discovered while painting landscapes. The silver, red, and green combination, for example, presented itself in a poppy field he painted, where silvery wild sage grew up the sides of a green slope. In the garden, he used a gray-leafed dianthus to represent the silver, while red geraniums with vigorous green leaves completed the color scheme. These color harmonies also found their way into his still life arrangements.

Cézanne's Garden

Both Monet and Renoir were friends of Paul Cézanne (1839–1906), who particularly liked to paint landscapes of trees that formed a cathedral of arching branches. Sometimes nothing more than a path led through the trees; other times the trees framed a landscape feature such as a farmhouse in an oasis of light at the end of the tree tunnel. When Cézanne established a garden of his own, he planted it richly with shrubs and trees, threading the one-acre (4,047 sq m) property with paths that twisted and turned. Today, the mature trees produce dense leaf tunnels, emulating the cathedral effects he painted. Cézanne declared that his favorite flower was the sweet scabious, but the still life plant he painted more than any other was the geranium. He liked the large ruffled leaves with their strong greens and brown zonal markings. Also, he admired the plant's sinuous stems, which gave a pronounced sculptural quality to arrangements.

Many of Cézanne's still life paintings show potted plants arranged on steps or on blocks of stone that he brought into the garden from local quarries to use as pedestals. He particularly liked the contrast of the slender, arching leaves of spider plants with the ivy-shaped leaves of geraniums.

In our quest to re-create in this volume the most beautiful of Impressionist still life arrangements, we have tried to present as wide a range of flowers and plants as possible and to present the work of many painters, including Post-Impressionists like Cézanne and the early American Impressionists like Childe Hassam. In some cases we have tried to make a close copy of the original arrangement, while in other cases we have used the painting as inspiration. In these instances we have borrowed an important shape or color harmony from the painting that captures the spirit of the original without exactly replicating the arrangement.

We have also sought to strike a balance between simple and elaborate arrangements as well as between indoor and outdoor locations. The simplest arrangements tend to come from van Gogh, who often gathered wayside flowers like thistles, cornflowers, and poppies and assembled them quickly into a spontaneous arrangement.

In the next part you'll find a discussion of the principles of creating Impressionist floral arrangements, which touches on color combinations, structural concerns, and ideas for placement. Following, in Part Two, you'll find step-by-step instructions on assembling each of twenty-four beautiful Impressionist arrangements.

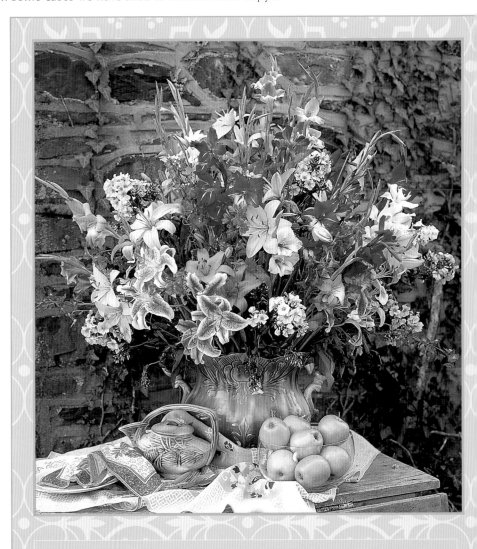

THIS IMPRESSIONIST-INSPIRED BOUQUET, WITH ITS RICH COLORS AND LUSH STYLING, RECALLS RENOIR'S EXUBERANT STILL LIFE PAINTINGS.

PART ONE

Creating Impressionist Floral Arrangements

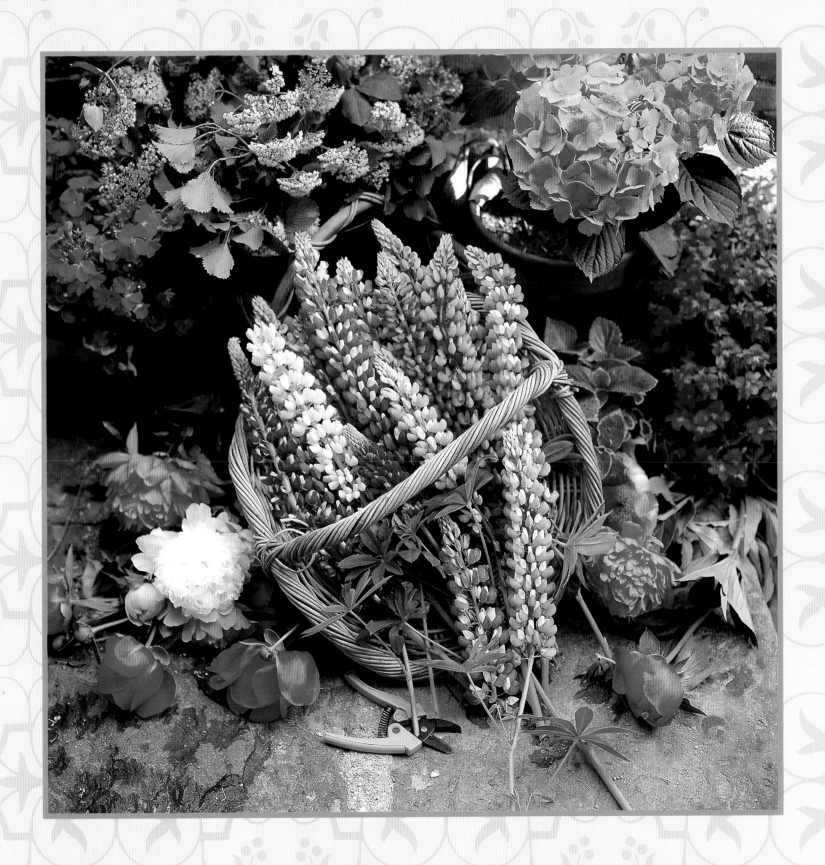

There is a similarity between the basic concepts of painting and the creation of a pleasing floral bouquet. Both disciplines rely heavily on composition and color for artistic expression. The main difference is that paintings involve a two-dimensional surface—the canvas on which paints are applied—while floral arrangements are three-dimensional. Instead of paints, floral designs use flower petals and leaves for color, and the room or outdoor setting serves as the canvas backdrop.

It is important to realize that at the time the Impressionist painters were creating still life floral arrangements there were no real guidelines to tell them what was considered good or bad floral design. They made their own rules of color, structure, and texture.

Each of the early Impressionist painters had preferences in the styles of arrangements they painted. Though some of the compositions seem little more than a few flowers placed in a vase, there is usually a strong element we can identify as artistic or distinct, worthy of re-creation or as a source of inspiration.

Monet, for example, produced many bouquets consisting of a mass of one particular flower variety, such as chrysanthemums or asters, in near-perfect symmetry. Often he simply selected a plant from his garden, cut it at the base, placed it in an appropriate container, and allowed the whole head to splay out, always making sure that the setting produced strong contrasts of sunlight and shadow.

Renoir, on the other hand, enjoyed elaborate bouquets, sometimes filling them with a wide range of flower shapes, sizes, and colors and presenting them in an exuberant style, such as the arrangement in *Spring Bouquet* (see page 43).

Van Gogh is the most interesting to study for design elements because some of his arrangements reflect his interest in Japanese still lifes, with their strong, simple, architectural lines, such as angular constructions of flowering apricot or plum branches.

For the purpose of analyzing the rather complex subject of flower arranging, it is best to examine the three essential components of any composition: inspiration, location, and elements of design.

NASTURTIUMS, EASY TO GROW AND RELENT-LESSLY CHEERFUL, WERE A FAVORITE CUT FLOWER OF THE IMPRESSIONISTS.

Inspiration

In this book we've used the paintings of the Impressionists as our inspiration because their choice of colors, structure, and form is refreshing and because they used common flowers we can easily grow in our own gardens. The masters of Impressionism, in turn, took much of their inspiration from nature, particularly from the color harmonies they saw in the surrounding landscape. Many of the painters were also admirers of Japanese art and of the flower paintings of the seventeenth-century Flemish painters, from whom the Impressionists took a fondness for simplicity of design and rich colors.

The bright or subtle hues of fabrics and sunsets, the brilliant plumage of birds, or the elaborate wing pattern of a butterfly can provide inspiration for a particular color harmony, while the silhouette of a tree in winter, grasses growing among wildflowers, or the tumult of a country meadow can provide inspiration for the architectural elements of a design. Let your observations of the world around you guide you in creating your own Impressionist designs.

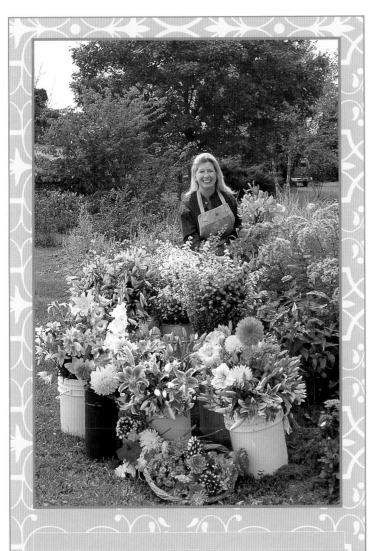

CAROLYN PRESIDES OVER BUCKETS OF FRESH FLOWERS HARVESTED FROM THE CUTTING GARDEN AT CEDARIDGE FARM.

Location

While the beauty of an arrangement itself is important, its position in relationship to its surroundings is almost as significant. Though many Impressionist flower paintings feature close-ups against neutral backgrounds, offering little sense of location, others show arrangements placed in intriguing, almost busy surroundings. For example, the shining Asiatic lily arrangement in Hassam's

Room of Flowers (see page 39) captures the warmth of Celia Thaxter's parlor. Cassatt's informal *Lilacs in a Window* (see page 31) is appealing because it evokes a sense of "country" with its view of a sunlit garden through hinged windows.

Ideal places for displaying arrangements inside the house include entrance halls, parlors, and sunny conservatories, as well as on dining room tables, fireplace mantels, and bedroom or bathroom vanity tables. Arrangements for dining room tables should be low so that people can see over them to converse, while entryways can feature tall and even extravagant arrangements if there is room. Outdoors, arrangements may be placed on picnic tables, balustrades, patios, or pedestals inside gazebos.

Do not overlook the power of fragrance to enhance an arrangement, especially in an indoor location. Flowers that have only faint scents outdoors can produce an uplifting fragrance in the confines of a room. Some popular fragrant flowers admired by the Impressionists include lavender, peonies, carnations, and roses.

PLEASING COLORS, A STRONG SENSE OF STRUCTURE, AND INVITING TEXTURES ARE KEYS TO A BEAUTIFUL IMPRESSIONIST BOUQUET.

Elements of Design

The most important design elements in an Impressionist floral arrangement are color, structure, and texture. Color, of course, was considered by the Impressionists to be the most important of these three elements, but a strong sense of structure is also evident in their arrangements.

Structure deals with line, spacing, and form—the overall "outline" of the arrangement. Texture, on the other hand, involves the physical properties of petals and leaves, and affects the way light is reflected from the arrangement. A rose's smooth leaf creates a lustrous sheen, while its petals have a satiny look.

Color

Color is the most appealing aspect of an Impressionist arrangement, and it is with flowers that the Impressionists loved to experiment. The Frenchman Eugène Chevreul invented the color wheel, which shows the relationships of colors and explains why certain colors make good companions. Though van Gogh considered the "laws" of color important to a sound art education, both Monet and Renoir downplayed the importance of these rules, stating that the inspiration for their best color combinations came from nature.

Reproduced here is a simplified form of the color wheel that Chevreul used to prove that the vast realm of colors is derived from mixing three primary colors—yellow, red, and blue. From these are derived three important secondary colors—orange, green, and violet. These six principal colors are the most important when considering color harmonies. Chevreul also noted that colors can be divided into "hot colors," such as yellow, red, and orange, and "cool colors," such as blue, purple, and green. He explained that hot colors tend to be assertive, or leap out at the viewer, while cool colors recede, creating an impression of depth. In particular, Chevreul described certain color harmonies as especially appealing. These are:

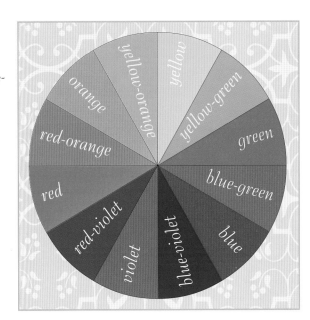

Monochromatic harmonies, which are composed of pure hues plus tints, tones, and shades of that hue—such as crimson red, rosy red, light pink, and deep pink. Avoid a dull arrangement by making one tone dominant—for example, a strong red paired with shades of pink as accents—and by adding white to enliven the closely related colors.

Analogous color harmonies, which are colors close to each other on the color wheel, such as yellow, orange, and red.

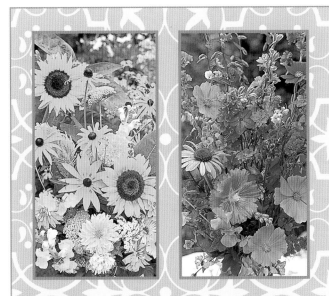

THESE MONOCHROMATIC HARMONIES MAKE USE OF MANY SHADES OF THE SAME COLOR TO AVOID A STATIC APPEARANCE.

Complementary color harmonies, which pair two colors opposite each other on the color wheel, such as yellow and violet, orange and blue, or red and green. Avoid equal amounts of each color and strive for a strong architectural quality using a variety of flower sizes and forms.

Triadic color harmonies, which combine three colors equidistant from each other on the color wheel, such as yellow, red, and blue. Choose one to dominate, as with the pink peonies in *Spring Bouquet* (see page 43).

ABOVE LEFT: THE WARM COLORS OF THIS POLYCHROMATIC HARMONY PROVIDE A STRONG THEME. ABOVE RIGHT: 'ZULU' AFRICAN DAISIES ARE ACCENTED WITH BLACK, CREATING DRAMATIC CONTRASTS IN ARRANGEMENTS.

Polychromatic harmonies, which offer a combination of many colors, like a rainbow. The simplest polychromatic arrangements involve the complete color spectrum of a particular plant species, such as a mixture of pansies or primroses (see *Barnhaven Primroses*, page 55).

Chevreul especially noted the importance of white, which itself can be coupled with black or other deep colors to make a strong contrast, and in fact van Gogh produced a number of arrangements that combined maroon flowers like hollyhocks with white flowers. Also, there are many white flowers with black centers, such as the African daisy 'Zulu'. In general, white is best treated as a hot color and used like glitter to enhance bolder colors, especially blue and red. Many white flowers are held in airy sprays—like baby's breath and feverfew—and these make excellent filler material.

Take care when using any of the primary colors (red, yellow, or blue) in combination, since they tend to project the same weight of color, which can be jarring. Instead, consider using one primary color as the main element and the others as accents.

Structure

Structure refers to the basic shape of a design. It determines whether an arrangement is formal or informal in style, for example, and helps to establish a particular design discipline, such as traditional, contemporary, or Oriental.

Structure also defines the "architecture" of an arrangement, or its sculptural quality. Cézanne was a master at organizing his flower arrangements with a clear sense of structure (see *Vase of Tulips*, page 51). He liked geraniums in particular because their long, sinuous stems and scalloped leaves were appealing to him even when the plants lacked color from sparse flowers.

The Impressionists liked spirelike flower stems like hollyhocks and spiky leaves such as iris and tulip foliage. They also appreciated the starburst effect in certain arrangements that resulted from bunching stiff, tapering flower stems, such as gladiolus, and letting them splay out in a fan shape, then mixing in daisy-shaped flowers. They also sought cascading effects (like the lilac flowers in Cassatt's *Lilacs in a Window*, page 31).

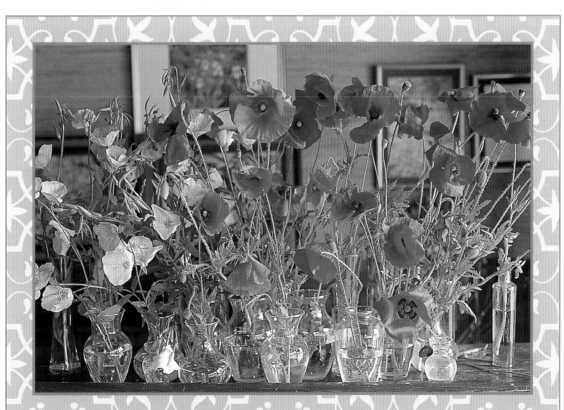

POPPIES WITH STEMS CUT TO DIFFERENT LENGTHS ARE ARTFULLY ARRANGED IN AN ARRAY OF GLASS VASES. TALL FLOWERS STAND AT THE BACK, WHILE THOSE WITH SHORTER STEMS NOD IN THE FOREGROUND, CREATING A SIMPLE YET EFFECTIVE STRUCTURE FOR THE ARRANGEMENT.

Structure also involves the spacing between elements as well as the type of vase an arrangement is placed in, whether round and bulbous or tall and square. The Impressionists particularly liked clear glass containers (see Manet's *Clematis in a Crystal Vase*, page 95) because the structure of stems can be seen through the glass.

Texture

For the Impressionists, texture had a lot to do with the quality of light that an arrangement produced, particularly from petals, leaves, and bark. The lustrous leaf of a rose, for example, gives an entirely different visual sensation than the velvety surface of a geranium leaf. Note how the dazzling satinlike sheen of yellow Asiatic lilies in Hassam's *Room of Flowers* (see page 39) is an important textural element in a room cluttered with old furniture, fabrics, and paintings.

Equipment

It is not by magic that the stems of an arrangement stay firmly in place, so some mechanism is sometimes needed to hold stems in the position we choose. It is important to remember that Oasis (a solid, spongelike material used to hold stems in place) is a fairly recent development and was not available to the early Impressionist painters. Indeed, they could not have used any internal mechanics in the clear glass containers that so many of them preferred for their arrangements.

Most of the arrangements created by the Impressionist seem to have been held in place by gravity and by carefully balancing stems against the inside of a container. A vase with a small neck and wide belly gives the most natural line, as the cut end of stems can rest against the inside wall of the vase, while the small opening gives them support. Tall, round, slim vases will hold

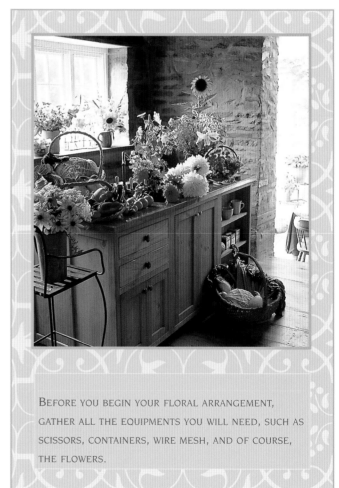

BEFORE YOU BEGIN YOUR FLORAL ARRANGEMENT, GATHER ALL THE EQUIPMENTS YOU WILL NEED, SUCH AS SCISSORS, CONTAINERS, WIRE MESH, AND OF COURSE, THE FLOWERS.

the flowers upright, but the flowers will still follow gravity and fall toward the sides, creating a fan-shaped design if arranged evenly. Low dishes are best used for short-stemmed flowers (as in the pansy arrangement in van Gogh's *Tambourine with Pansies*, page 35), but a large number of flowers is usually needed for a successful arrangement. Often the choice of container dictates the number of flowers that should fill an arrangement.

We prefer to use only gravity, networks of stems, and the dynamics of the container to hold the flowers in place when creating Impressionist-style arrangements, but in a few cases a little extra support is needed, as in van Gogh's arrangement *Vase with Iris Against a Yellow Background* (see page 107). It is difficult to make this arrangement stand on its own without some internal mechanics, and in replicating van Gogh's arrangement we plugged the inside of the container with a dome of crumpled chicken wire and inserted the iris stems through the wire mesh to hold them securely erect in the distinctive fan shape composed by van Gogh. If any internal mechanics are necessary to these arrangements, they are mentioned in the materials list.

In discussing each of the following featured arrangements, we use three terms to describe the floral content: main, fill, and accent material. Main material is generally the most obvious element in a particular design, and it is usually the most abundant plant in the composition. In essence main material is the focus of the arrangement. Fill material is traditionally used to fill gaps between flowers, which gives the overall design a full and cohesive appearance. Fill is often used to add sparkle to an arrangement (with airy white flower sprays, for example) or to create a background color against which the main material can be observed, similar to the artist's practice of painting in a sky before adding the trees and buildings. Accent material punctuates a design and is most commonly used to introduce a second harmonious color. Accents can be flowers, but may also be twigs, leaves, and berries or other fruits.

In the following arrangements, we've provided a materials list that tells you exactly what you'll need to create each arrangement. Note that in cases where a particular species or cultivar is important, we've noted it in parentheses beside the plant's common name. In other cases, any variety will work and we've simply listed the common name.

Following the materials list is a brief discussion of the necessary conditioning for the flowers. This step is extremely important to ensure the longest vase life. Step-by-step instructions guide you in assembling the arrangement, but remember that a certain amount of flexibility and inspiration is what will make your arrangement truly special. Let your eye for pleasing color combinations and interesting lines help you find your own Impressionist muse.

PART TWO

The Arrangements

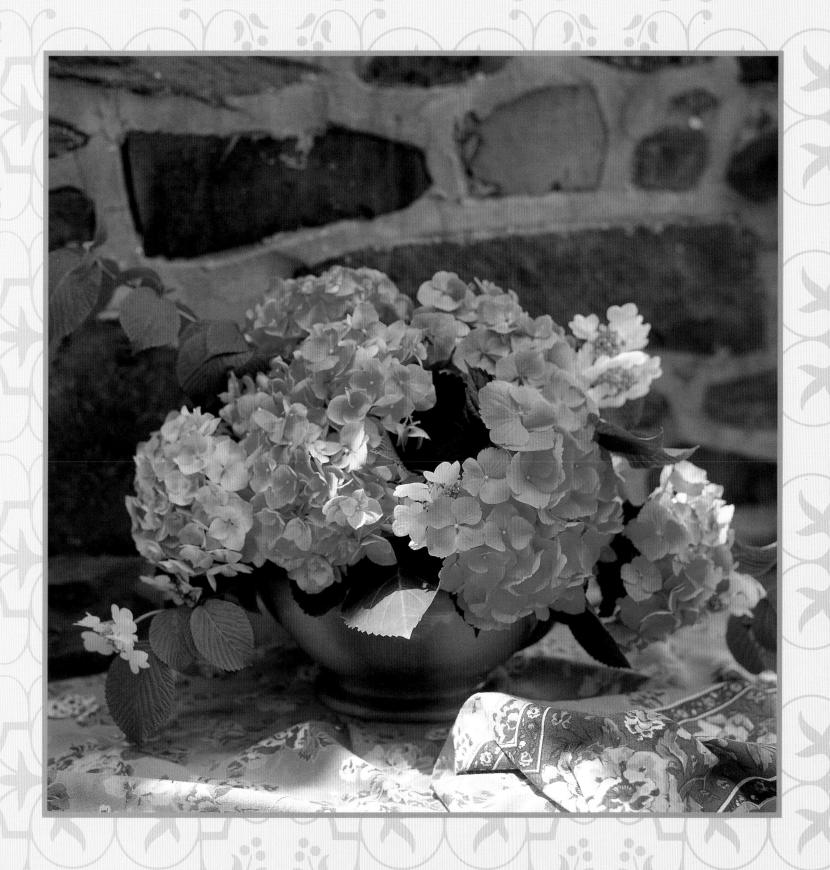

Lilacs in a Window

Mary Cassatt
Oil on canvas; 1889; private collection

Lilacs in a Window shows a beautiful massed bouquet of common lilacs on what appears to be the window ledge of a greenhouse or conservatory with a view of a sunlit garden. Lilacs feature prominently in many Impressionist paintings, either alone or partnered with other cut flowers.

Lilacs are spring-flowering plants, and they are so fragrant that just a few blossoming stems can fill a room with an uplifting aroma. There are more than thirty species, mostly indigenous to Asia, but the common lilac (*Syringa vulgaris*) is the most widely grown, the hardiest, and the most widely adaptable, tolerating even poor soils. French nurseries in particular have produced a large number of distinct varieties, popularly known as French Hybrids. Colors range from deep purple, rosy reds, and pale pinks through delicate lavender-blue and powder blue to pale yellow, cream, and white.

Mary Cassatt's painting makes use of the wonderful pastels of lilac blossoms, and her style reflects her admiration for Edgar Degas' painting technique and its assimilation of Japanese art. Although Cassatt's bouquet itself is not noticeably Japanese in style—in fact it is more typical of the full and exuberant French country style—the placement of the arrangement is very much in

the Japanese tradition. The lilacs rest on a windowsill, thus connecting the indoor environment with the natural beauty of the countryside beyond. It is these details, coupled with the graphic, boldly defined figures and clear colors of her later work, that link Cassatt with the Japanese style of painting, perhaps more than any other Impressionist painter.

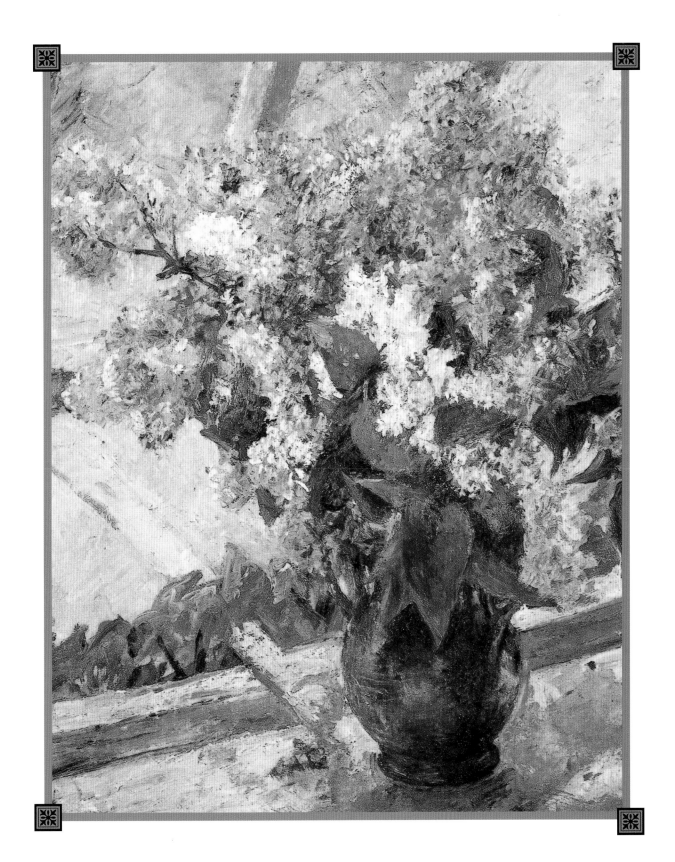

*T*o capture the wonderful sense of springtime in Mary Cassatt's painting, with its strong sunlight and garden of bright greens, we have chosen to feature a similar exuberant bouquet of lilacs outdoors. The rails of the deck provide geometric lines like the windowpanes in Cassatt's painting, and make an appealing contrast with the soft, billowing lines of the arrangement.

Making the Arrangement

1. Fill the container three-quarters full of tepid water.

2. Assemble all the conditioned flowers and remove any leaves that will fall below the waterline. Be sure to give each flower a fresh cut on an angle before tucking it into the arrangement.

3. Begin with the main material, placing 3 branches of the lavender-blue lilac into the container. This will create the outline of the arrangement.

4. Place the remaining 2 branches of lavender-blue lilac directly into the center of the arrangement. Make sure the general outline of the arrangement is one and a half times the height of the container.

5. Add the branch of white lilac to the heart of the arrangement, allowing it to cascade slightly forward over the rim of the vase.

6. Add the azalea to either side behind the lavender-blue lilac. Adjust the azalea so that it cascades out and down, but is almost hidden.

7. Place the forget-me-nots, bunching them together as if they were one stem, in front of the lavender-blue lilac and above the white lilac. The deeper blue against the lavender-blue creates the effect of a shadow. Adjust the green lilac leaves so that they point downward, concealing half the container.

8. Place the finished arrangement on a small table or nightstand, where the delicate blend of pastel colors and the heady perfume can be fully savored. Lay the branch of honeysuckle near the base of the vase for a painterly touch. Top off the container with tepid water.

Overall Dimensions
23" tall, 18" wide

Materials
- Ceramic full-belly vase, 8" tall, with a 6" belly and a 4"-diameter mouth

MAIN MATERIAL
- 5 branches old-fashioned lavender-blue lilac (*Syringa vulgaris*), 18" to 24" stems
- 1 branch white French hybrid lilac, 15" to 18" stem

FILL MATERIAL
- 1 branch pale pink azaleas, 24" stem
- 1 branch pale pink honeysuckle (*Lonicera heckrotti*), 24" stem

ACCENT MATERIAL
- 10 blue forget-me-nots (*Myosotis alpestris*), 15" stems

Conditioning
The hard-stemmed lilacs, azaleas, and honeysuckle need special care to ensure that they stay fresh as long as possible. Remove 2" to 3" of bark from the cut end of each stem, then make two slits lengthwise where the bark has been removed. This opens up more surface for water absorption. Once all the flowers have been gathered, place them immediately in a bucket of warm water up to their necks. Leave in a cool area for 12 hours or overnight.

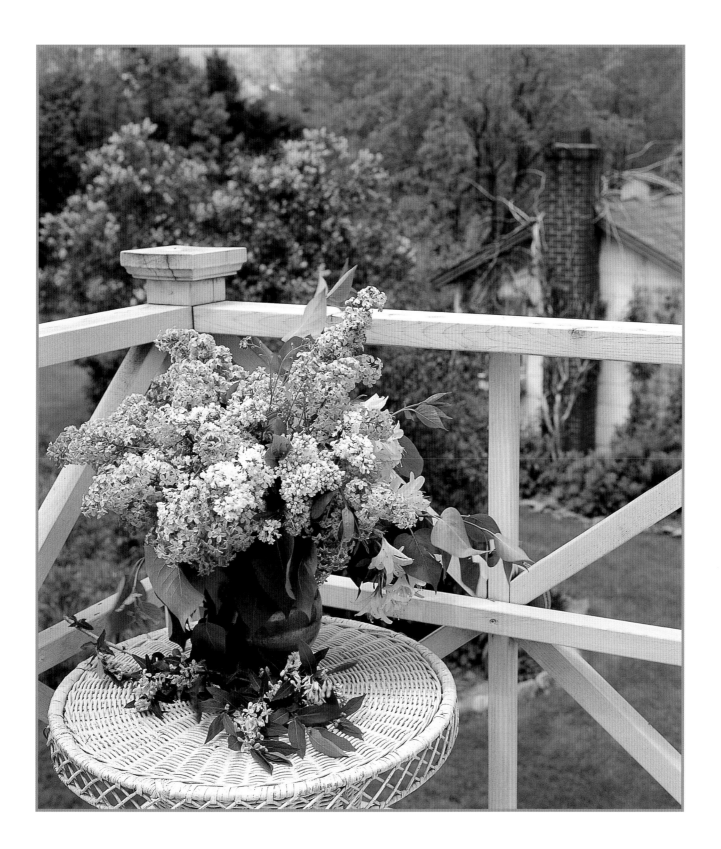

Tambourine with Pansies

Vincent van Gogh

Oil on canvas; 1886; Vincent van Gogh Museum, Amsterdam

The markets of Montmartre and Paris were filled with fresh flowers, many shipped by train from France's cut-flower industry centered in Nice, and when van Gogh moved to Montmartre he produced a frenzy of still lifes, the flowers mostly chosen as experiments in color harmonies. *Tambourine with Pansies* is among his first still life paintings of a floral arrangement after moving to Paris.

The Impressionist painters loved to grow pansies in their own gardens and also liked to paint them, though van Gogh was the most diverse of the Impressionist painters in his selection of flowers as motifs, including not only garden flowers but wayside flowers, thistles, and grasses gathered during walks in the countryside.

In this arrangement van Gogh has arranged a handful of blooms and stems in a shallow wicker basket on top of a Gypsy tambourine. The flower colors appear to resemble closely a popular mixture today known as 'Antique Shades', whose predominant colors are rosy pinks, orange, apricot, and pale yellow. Pansies are easy to grow from seed, and are available as mixtures, which seedsmen have blended to make special color combinations. In addition to the 'Antique Shades' that come close to van Gogh's palette in this painting, there are pink, blue, and pastel shades.

Prior to this watershed painting, van Gogh's works were executed in extremely somber tones. From this juncture on he falls under the influence of Impressionism, and his still life designs become progressively more bold and colorful, as do his choice of flowers and painting technique.

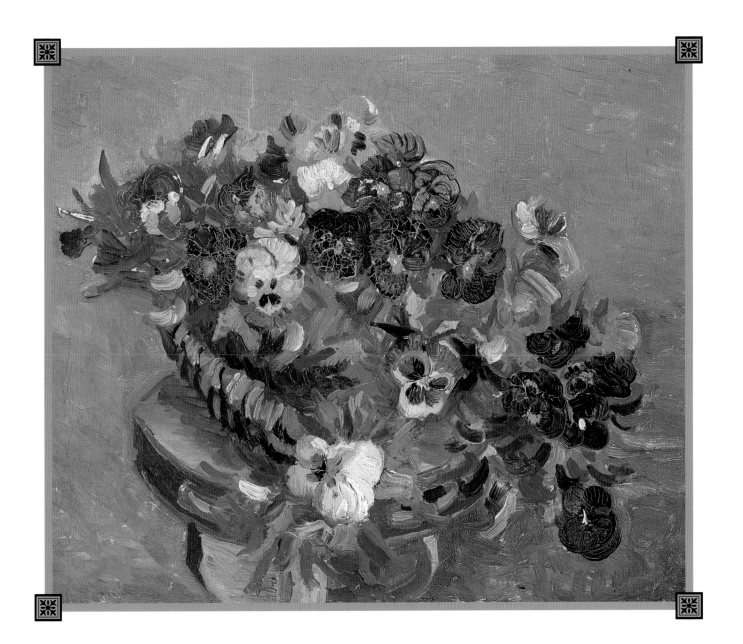

*T*his arrangement has the advantage of being low, and so we have placed it on a low table beside a window of our dining room. Indeed, the entire arrangement can be moved to the center of the dining room table to make a colorful centerpiece, as arrangements for the dinner table are best when guests and family members can see over them.

For the container we have chosen a dark, shallow, coarsely woven wicker basket, adding a clear glass soup dish inside as a liner to hold water. The brilliant colors of the Gypsy tambourine inspired us to place our pansy arrangement on a handsome multicolored circular Mercer tile, a mosaic of colors that complements the lively hues of the pansies.

In addition to being quick and easy to make, this arrangement of pansies has a delicate perfume and will last a week or more as cut flowers.

Making the Arrangement

1. Place the liner inside the basket and fill it half full of tepid water.

2. Give each stem a clean cut before adding it to the arrangement. Begin by laying an edging of pansies around the rim of the container. Allow the necks of some flowers to rest on the edge of the liner so that it is hidden from view.

3. Continue to add flowers in a swirling pattern toward the center, making sure each stem is deeply submerged in the water. Allow leaves and unopened buds to be part of the design, letting each flower slightly overlap the previously positioned one. Group similar colors together to form a natural, relaxed pattern throughout the design.

4. Place the arrangement on a brightly colored circular tile or a madras tablecloth that echoes the colors of the pansies. Check on a daily basis to ensure that the container is always full of water.

Overall Dimensions
5" tall, 12" wide

Materials
- Low wicker basket with 2" sides and no handle to obscure blooms
- Clear basket liner, such as a glass soup bowl
- 50 pansies in a mix of colors ('Antique Shades' preferred), 3" to 4" stems

Conditioning
Cut the pansies close to the root, removing any leaves from the bottom half of the stem and any seedpods or overmature flower heads. Place the flowers in a shallow dish filled with lukewarm water and leave in a cool area for several hours or overnight.

The Room of Flowers

Childe Hassam

Oil on canvas; 1894; Collection of Mr. and Mrs. Arthur G. Altschul

Childe Hassam is considered to be one of America's best early Impressionist painters, and one of the most prolific, producing more than four thousand works of art in oil, watercolor, and pastel over a long and distinguished career. *The Room of Flowers*, Hassam's most celebrated painting, shows a romantic view of the parlor of poet Celia Thaxter, which in the summer became a celebrated salon for artists and literary figures. One-tenth of Hassam's body of work, approximately four hundred paintings, was produced on the Isles of Shoals, a remote cluster of small, rocky islands off the southern coast of Maine. The attraction for him was not only the solitude and the vast seascapes that were a favorite motif, but also Celia's house and garden.

In this painting, sunlight streams through the windows, vases of flowers brighten the room still further, and a young woman reclines on a sofa in a room that is so filled with paintings and other furnishings that she herself almost melts into the background. This painting is an example in which the setting is as important as the bouquet, and the lush and comfortable room offers an elegant backdrop for the flowers, which in turn benefit from the refined surroundings.

In the foreground of the painting stands a fluted clear glass jar of yellow Asiatic lilies; delicate touches of sunlight on the petals and greenery produce a sensational gold and green color combination. Clusters of flowers in more clear glass vases stand on an Oriental-style table in the middle of the room and also on another table and on the sideboard in the back, the entire ensemble evoking a wonderful sense of intimacy and good cheer.

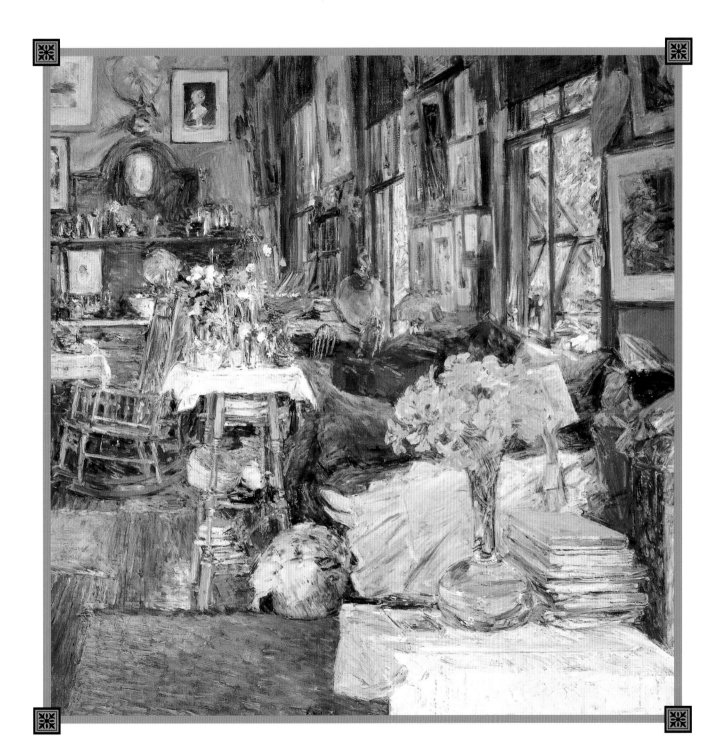

*A*h, if only every room could be a room of flowers! The arrangement we have chosen to replicate from Hassam's painting is the vase of yellow Asiatic lilies in the foreground. The petals have a satiny sheen and seem to radiate a glowing light like the rays of the sun. The bulbous base of the vase contributes a note of practicality since it gives stability to the slender, fluted neck. When filled with water the vase is not easily knocked over.

Asiatic lilies are an ideal cut flower, and provide the most extensive color range of all the garden lilies. In addition to yellow, there are orange, red, pink, purple, and white, as well as bicolors. They flower in late spring and hold their flowers up like a chalice. The Impressionists also admired the large-flowered, summer-blooming Oriental lily, which has exotically spotted petals in pink, red, and white and which hangs its head sideways. Oriental lilies bloom in summer and are delightfully fragrant.

Making the Arrangement

1. Fill the container three-quarters full of tepid water.

2. Because the petals of lilies are easily bruised or ripped, carefully lay each stem so that the flower head protrudes past the edge of your work table.

3. Begin the arrangement by choosing the longest stem to make the tallest part of the dome shape of the arrangement; the top of the dome should be one to one and a half times the height of the container.

4. Add flowers, working from the center outward. Before you add each new stem, cut it (making sure to slice on an angle) slightly shorter to create the pronounced mound shape. Leave space between the flowers to give the unopened buds room to expand.

Overall Dimensions
28" tall, 15" wide

Materials
- Tall, flared crystal vase, 12" tall, with straight or slightly bowed sides and a 3"-diameter mouth
- Floral preservative
- 15 to 20 golden yellow Asiatic lilies such as 'Sun Ray' or 'Connecticut King', stems 26" to 30", graduated to create the domed shape

Conditioning
If you are cutting lilies from the garden, choose clusters where only the first flower has started to open. If you are buying from a florist, select stems that have several unopened buds rather than those with all flowers fully open. This will greatly increase the life of the arrangement, allowing unopened buds to mature and to fill in the design.

Remove almost all the leaves from the stems, leaving only 2 or 3 at the very top next to the flower head, and place the flowers in a full bucket of warm water, immersing the stems up to the remaining leaves. Lilies are especially receptive to the benefits of a floral preservative added to the water at this stage of conditioning. A teaspoon of bleach to kill bacteria and a teaspoon of sugar to provide nutrients can substitute for a commercial preservative.

Spring Bouquet

Pierre-Auguste Renoir

Oil on canvas; 1866; Fogg Art Museum, Cambridge, Massachusetts

Spring Bouquet was painted early in Renoir's career, in the company of the artist Claude Monet, whom Renoir had met when both were students at the Gleyre Studio in Paris. Painted outdoors on the balustrade of a terrace, the work was probably completed over a weekend stay at Montgiron, the country estate of a generous patron of the Impressionist movement. Renoir, the most famous colorist among the Impressionists, spotted the bouquet indoors but moved the flowers outside so that he could paint in natural light.

The original painting had a blue, pink, and white color motif, with the blue from lilacs, the pink from peonies, and the white from a combination of bearded irises, marguerite daisies, sweet scabious, and a late-flowering daffodil called 'Actaea', which has a double form that resembles a gardenia. There are also touches of yellow in the arrangement, lent by laburnum blossoms and Siberian wallflowers. Over the years, unfortunately, the pink tones of the painting have faded, so today it appears to be mainly a composition in blue and white.

Notice also the variegated foliage from a pale pink weigela at the tip of the arrangement, and the silvery sheen of sedum leaves just below. Other leaves in the arrangement are smooth

and lustrous, whether they are the spiky blades of irises and daffodils or the serrated leaves of marguerite daisies. This design is not merely a beautiful study of flowers, but a celebration of leaf patterns and textures.

Renoir's joyful rendering evokes the lavish flower paintings of the Flemish still life painters, but his expressive handling of paint projects a feeling of carefree profusion and abundance that is particularly his own.

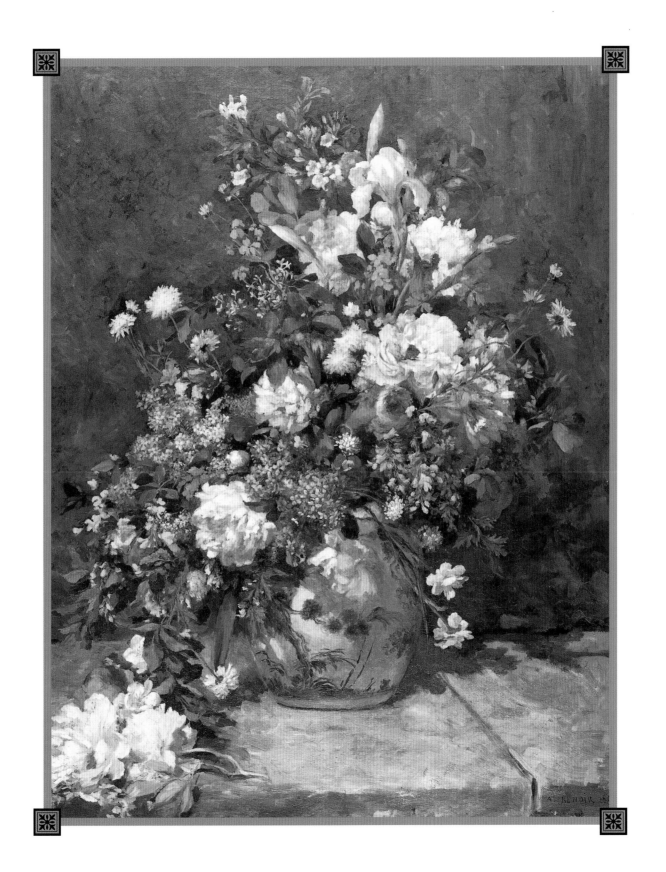

*O*ur arrangement is faithful to Renoir's original color scheme, keeping the old-fashioned, full-bodied flowers that appear in the still life—pale pink peonies, white bearded irises, and lavender-blue lilacs. We have retained the double daffodils but have made some substitutions for difficult-to-find plants like sweet scabious and weigela. Because the powdery blue shade of the lilacs used by Renoir is difficult to find, we've heightened the blue tones by adding forget-me-nots.

Making the Arrangement

1. Fill the container three-quarters full of tepid water and remove from branches and flower stems any leaves that would fall below the waterline.

2. Using the fill material, first create the overall free-flowing outline of the arrangement, making sure that the outline is approximately twice the height of the container. Use the honeysuckle and euonymus to create height and the viburnum and azaleas to establish a strong central axis. Check the outline of the arrangement and adjust any material that looks awkward.

3. Position the main material: begin with the lilacs, placing them at the heart of the arrangement, and add the white irises throughout to establish a strong vertical line. Place the peonies to create a gentle flow through the design, allowing one flower to droop over the edge of the container for an informal, tousled look.

4. Bunch together the stems of each accent flower and place them firmly throughout the arrangement. This creates a sparkling effect, one of the charactaristics of the Impressionist style.

5. Place the finished arrangement in a location where the dramatic flowers and full, robust design can be best appreciated. Tossing an extra blossom beside the vase adds a very painterly appearance, especially in an outdoor setting. Top off the water in the container.

Overall Dimensions
35" tall, 26" wide

Materials
- Crock in white and blue, 13" tall

MAIN MATERIAL
- 2 or 3 blue or lavender-blue old-fashioned lilacs, 12" to 18" stems
- 2 white bearded irises (*Iris* × *germanica*), 24" to 30" stems
- 6 or 7 pale pink peonies, 18" to 24" stems

FILL MATERIAL
- 1 branch creamy honeysuckle, 30" stem
- 1 branch white viburnum, 30" stem
- 1 branch blush pink or white azaleas, 24" stem
- 1 branch variegated euonymus, 36" stem

ACCENT MATERIAL
- Insert in a florist's vial if stems don't reach the water.
- 5 or 6 forget-me-nots, 12" stems
- 6 primroses, 8" stems
- 6 double 'Actaea' daffodils, 15" stems

Conditioning
Plunge peony stems into a bucket of warm water as you cut them. For hard-stemmed plants remove 2" to 3" of bark from the cut end of the stem, then make two 2" to 3" slits lengthwise for better water absorption. For all flowers, place in a bucket of warm water up to the necks and place in a cool area for at least 12 hours.

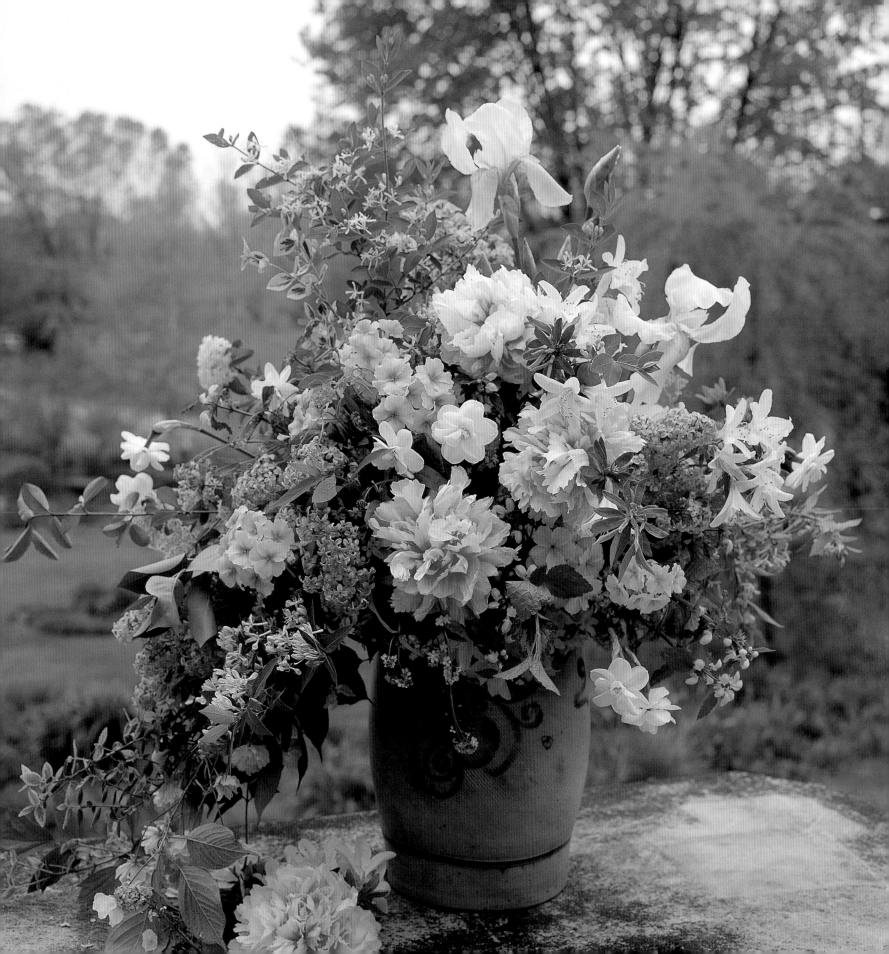

Geraniums

Childe Hassam

Oil on canvas; 1888; Hyde Collection, Glens Falls, New York

Geraniums were as common in the late nineteenth century as they are today, but the fact that they were overused in parks and public gardens for carpet bedding made them no less dear to the Impressionists. Red and green are complementary colors, and the Impressionists thought that the vigorous green of geranium leaves and the intensity of the red flowers were the perfect partnership for this dramatic color harmony.

In his painting *Geraniums* the early American Impressionist painter Childe Hassam capitalized on the strong reds and greens of the summery flowers, showing them displayed in tiers beside a balcony in France. Though the plants sit in a shadowy area, bright sunlight illuminates the stucco walls in the background, creating a study of sunlight and shadow. Two cast-iron watering cans in the foreground add a strong textural contrast to the flowers, while a tall, spiky oleander shrub to one side adds an upright sculptural quality as well as providing contrast in leaf form.

Geraniums seems to form a partnership with two other works Hassam painted in France. *Gathering Flowers from a French Garden* (1888) shows a young woman in her garden with baskets of peonies ready to take into the house, while *At the Florist* (1889) shows two Parisian women pur-

chasing bouquets of flowers from a street vendor. Viewing these magnificent paintings today, one cannot help but wonder whether the Western world has lost some of the passion for flowers that is so evident in this triad of paintings.

Though not strictly bouquets, potted geraniums make a decorative long-lasting display. A flight of steps, a balcony, or a garden path can provide the perfect location for an arrangement of potted geraniums inspired by Hassam's powerful painting.

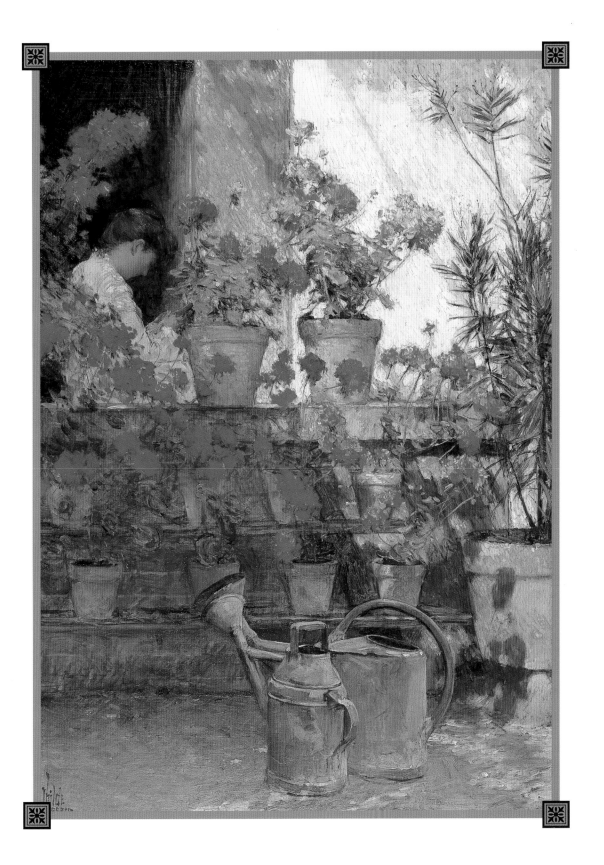

\mathcal{M}aking a floral display with potted plants is as creative and rewarding as making one with cut flowers. Indeed, the exercise can be more satisfying because the potted plants can last all summer. Balconies, front and back porches, gazebos, and walkways are all good settings for an artistic collection of flowers displayed in an appealing outdoor vignette.

In our representation of Hassam's painting, we have not only used the popular red bedding geranium but also added some cascading ivy-leaf geraniums of the kind admired by Cézanne. Though grown mostly as annuals because they are ever-blooming, geraniums are really tender perennials. After a summerlong flowering show and before frost, they can be taken indoors and placed in a conservatory or sunny window to continue blooming during the winter months. When the plants become leggy and flower sparsely, simply cut the stems back to the soil line and transplant to a larger pot to stimulate new flowering growth.

The colors of flowers, leaves, and containers are the most important elements in potted arrangements. Here, red, pink, and bicolored geraniums set the tone for a dramatic complementary color harmony of mostly red and green. A softer pink among the red geraniums is important, as it creates an illusion of sunlight and shadow.

Making the Arrangement

1. Determine the right location for the display. If you do not have stone steps or a terrace, deck, or balcony on which to set plants in tiers, consider using a stepladder, placing the pots on each step of the ladder.
2. Provide full sun or a location that receives at least 6 hours of sunlight. In a shady location, substitute red and orange tuberous begonias for the sun-loving geraniums.

Overall Dimensions
15' long, 5' wide

Materials
- 13 terra-cotta clay pots in various sizes
- 1 or 2 old watering cans
- 24 red bedding-type geraniums in 8 clay pots, 3 plants per pot
- 2 red cascading ivy-leaf geraniums in 2 small pots, 1 plant per pot
- 6 pink ivy-leaf geraniums in 2 clay pots, 3 plants per pot
- 2 bicolored ivy-leaf geraniums in 1 clay pot

Conditioning
Use equal parts of a peat-based potting soil and screened topsoil to fill the pots, ensuring that drainage holes are covered with broken crockery to keep them from getting clogged. Water the pots whenever the soil surface feels dry. Remove spent blossoms to force new flower buds.

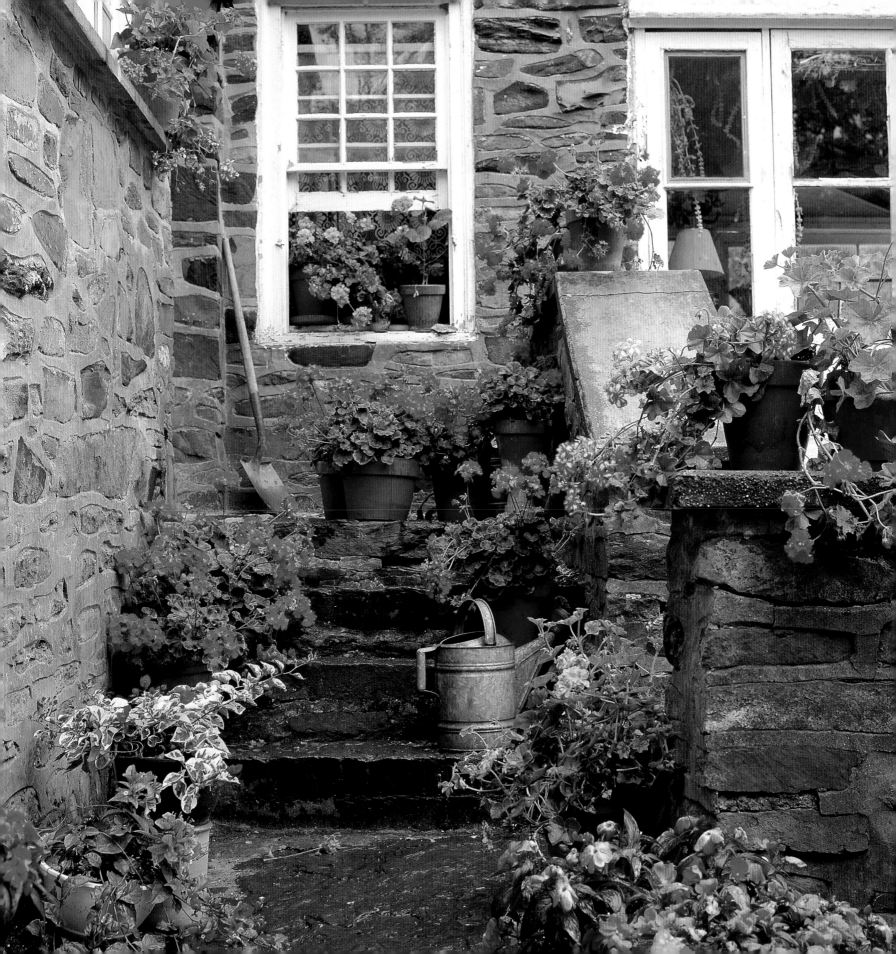

Vase of Tulips

Paul Cézanne

Oil on canvas; 1890–92; Art Institute of Chicago

Tulips—with their wide range of colors and flower forms—appealed to many of the French Impressionists. Cézanne especially admired the lily-flowered kinds, which possess elegant, pointed, reflexed petals with a purity of color unmatched by other members of the tulip family. This flower variety is so beautiful and distinctive that it makes a still life arrangement worth repeating whenever it is in season. At Cedaridge Farm we now grow no other tulip variety for cutting.

In Cézanne's painting two lily-flowered tulips in reddish tones are the focus of the arrangement. As accents he used 'Actaea' daffodils, fragrant late bloomers with porcelain white petals and a dainty green eye rimmed with yellow and red. As fill, Cézanne used buttercups that he probably found in a woodland clearing on his property. The leaves in the arrangement—one ruffled and arching (a tulip leaf), three tall and spiky (iris leaves)—are beautiful sculptural elements that lend the arrangement its Japanese look.

Cézanne was fond of embellishing his floral still lifes with fruit around the base of the container as a link to the location of the arrangement. *Vase of Tulips* features soft-colored peaches that lend an informal, earthy look to the design. To add a similar unifying element, other Impressionist painters sometimes pulled flowers or leaves from the design itself to lay around the arrangement's base.

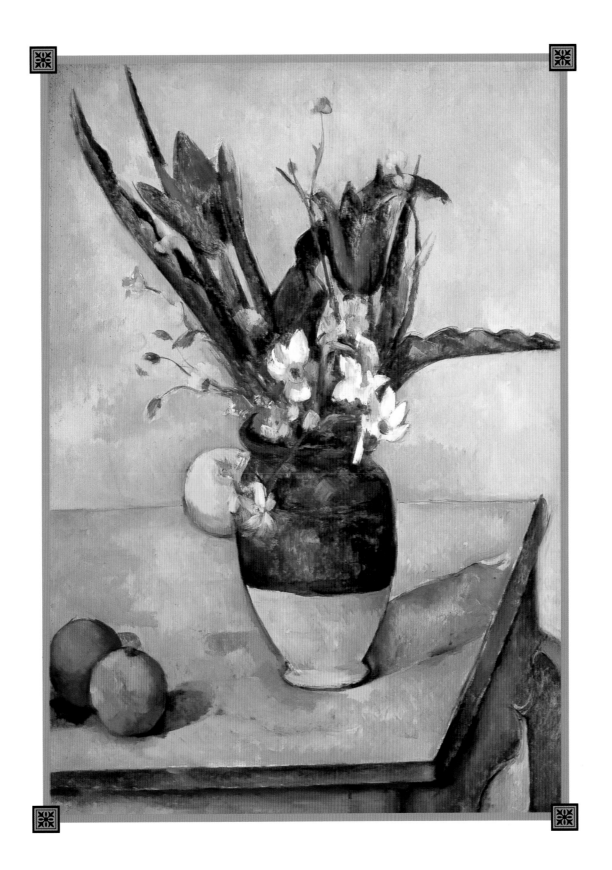

In our arrangement we have chosen to capture the same Japanese quality of Cézanne's design, and have used flowers identical to those in the painting. Note that any old variety of tulip will not do. The tulips must be the lily-flowered kind. We have placed the arrangement on the side table of a sunny room with French doors that open to a panoramic view of the garden beyond, further linking the floral design to the landscape.

Making the Arrangement

1. Fill the container three-quarters full of tepid water.

2. Gather together all the flowers you will need, giving each a fresh cut before adding to the container.

3. Begin arranging with the main material by placing the 2 lily-flowered tulips in the vase. The stems must touch the bottom of the container, allowing the flower to stand erect. Adjust the flower heads so that they gently lean away from each other, creating a definite separation between them.

4. Add the fill material, positioning the upright iris leaves to the left of the tulips. Put 1 of the rippled tulip leaves to the back of the arrangement and 1 to the right side, allowing them to fall over the edge of the container.

5. Add the accent flowers, adjusting the daffodils, jonquils, and buttercups to create a soft, natural composition. Tuck the daffodils and buttercups close to the opening of the container.

6. Check the water in the container, topping off whenever the level is low. Place the peaches or nectarines beside the vase.

Overall Dimensions
30" tall, 15" wide

Materials
- Black ceramic perfume display container, 9" tall, 8" wide, with a 2"-diameter mouth (Note: This container is mostly solid, with only a 2" channel, which maybe simulated by adding a thin jar such as an Alka Seltzer bottle.)

MAIN MATERIAL
- 1 deep red lily-flowered tulip (such as 'Red Shine'), 18" stem
- 1 deep pink lily-flowered tulip (such as 'Marietta'), 16" stem

FILL MATERIAL
- 3 Japanese iris leaves (*Iris ensata*), 28" to 39" long
- 2 rippled lily-flowered tulip leaves, 16" long

ACCENT MATERIAL
- 4 single-flowered poet's daffodils (*Narcissus poeticus* 'Actaea'), 6" to 7" stems
- 1 cluster-flowered bright yellow jonquils, 8" stem
- 3 clusters of wild yellow buttercups, 12" stems
- 3 rosy peaches or nectarines

CONDITIONING
Wrap tulip stems with florist's tape, then roll with newspaper before placing in a bucket containing 2" to 3" of warm water. Add the iris and tulip leaves to the same bucket. Place daffodils, jonquils, and buttercups in another container in warm water up to the flower heads. Place all the flowers in a cool location for 12 hours or overnight.

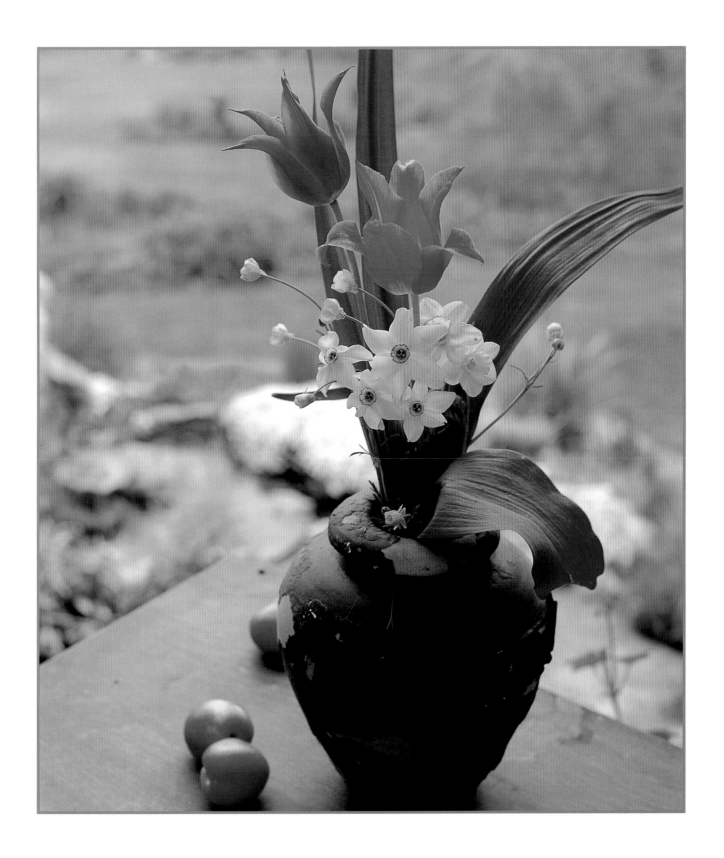

Barnhaven Primroses at Cedaridge Farm

Lois Griffel

Oil on canvas; 1997; collection of Mr. and Mrs. Derek Fell

During the age of Impressionism, Europe experienced an explosion in gardening interest and technology. Labor-saving devices such as the lawn mower and the watering hose were invented, and so many new plants were introduced into cultivation from exploration throughout Japan and China that the period is now known as the Golden Age of Horticulture. Famed Victorian plantswoman Gertrude Jekyll developed especially beautiful primroses called 'Munstead' hybrids, named after her home and garden in the south of England. Fifty years later an Oregon housewife bought a packet of primrose seeds derived from the 'Munstead' hybrids, and over a period of forty years she conducted her own hybridizing at her home, Barnhaven. She produced the finest strain of primroses the world has ever seen and named it after her home. These primroses are still available through a nursery in France (see page 127).

'Barnhaven' primroses are a delight to arrange. Most have umbels of flowers tightly packed with florets on long, strong stems. Some are in clear colors with no contrasting eyes; others have as many as three color zones in the flower. A particularly beautiful group has pendant, bell-shaped flowers like old-fashioned English cowslips. The colors of 'Barnhaven' primroses are astounding—not only the yellow, red, blue, and white common among primroses, but orange and apricot, maroon and violet, brown, and even light green, some of them in double forms. The arrangement features a polychromatic harmony of mostly hot colors on a matching tablecloth. Afternoon sun backlights the leaves of flag iris in the background, and an old Bucks County farmhouse is silhouetted on a hillside beyond. The painting has special appeal because of the proximity of the arrangement to the plants in the garden.

*B*ecause the primrose is such a strong symbol of spring, we delight in using it both indoors and out as a table centerpiece, where its exquisite beauty can be appreciated from close quarters. We also like to select whimsical containers, such as the Ohio pottery teapot used here. The depth of color of the yellow ceramic and the squat shape of the teapot make it a perfect container to highlight the pure, warm colors of the flowers.

When selecting flowers to cut, choose stems with flowers that have just opened. This freshness will ensure a vase life of 5 or 6 days.

'Barnhaven' primroses are best arranged informally, giving the look of a freshly picked bouquet. Allow a few stems to stand out from the main mass of flowers. The florist variety 'Pacific Giants' may be substituted in place of 'Barnhaven' primroses.

Making the Arrangement

1. Fill the teapot three-quarters full of tepid water and add the floral preservative.

2. Rim the edge of the container with a selection of primrose colors, choosing hot colors such as yellow, scarlet, and orange.

3. Continue adding flowers from the outer edge toward the center, placing the colors so that they flow from one tone to another—scarlet next to orange next to yellow, for example. Be careful not to allow a repetitious pattern in the color placement. Allow some stems to stand taller in the middle to give a carefree, just-picked look.

4. Place the completed arrangement on a small table covered with a cloth of equally bright, warm colors to create the effect of a color echo.

5. Top off the container with water. Add brightly colored 'Gala' apples or peaches to provide another color echo.

Overall Dimensions
15" tall, 18" wide

Materials
- 1 ceramic teapot (lid is not necessary) with a 6" neck opening
- Floral preservative

MAIN MATERIAL
- 24 'Barnhaven' primroses, 6" to 8" stems, as follows:
 - 8 stems bright yellow
 - 4 stems deep burgundy
 - 4 stems scarlet
 - 4 stems bright orange
 - 2 stems bright pink
 - 2 stems blue

ACCENT MATERIAL
- 2 or 3 'Gala' apples or peaches (optional)

Conditioning
Immediately place the cut flowers in a bucket of warm water. Leave in a cool place for 24 hours before assembling the arrangement.

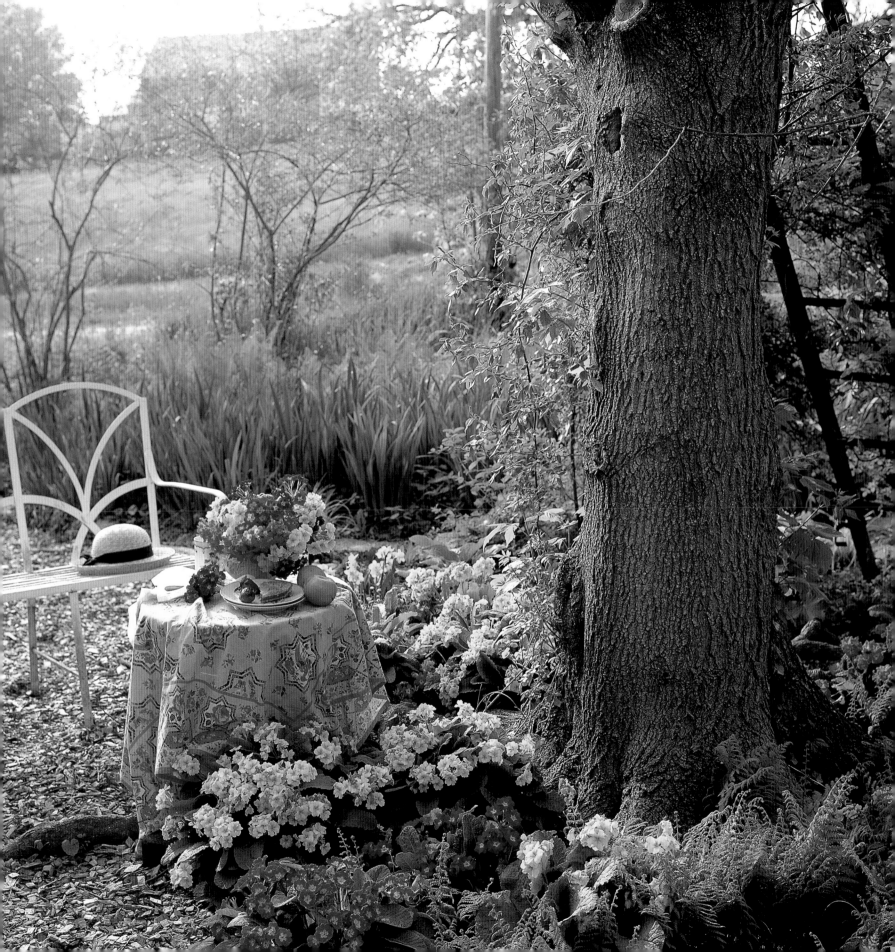

Vase with Twelve Sunflowers

Vincent van Gogh

Oil on canvas; 1888; Neue Pinakothek, Munich, Germany

The series of sunflower paintings by van Gogh shows two kinds of sunflowers—single-flowered and double forms—with the arrangements sometimes combining the two. He may have been inspired to paint the sunflower series as a result of seeing a beautiful sunflower arrangement by Monet, who in turn was encouraged to paint sunflowers by Gustave Caillebotte. In a letter to his brother, van Gogh expressed the opinion that Monet's sunflower painting was better than his own, though his friend Gauguin disagreed. The sunflower series was so satisfying to van Gogh, and so highly praised by Gauguin, that van Gogh declared the flower as his own, stating in a letter to his brother: "You know the peony is Jeanin's, the hollyhock is Quost', but the sunflower is mine...."

What we admire about both Monet's and van Gogh's sunflower still lifes is the dramatic impact the flowers present used alone, with no embellishment needed from accessories or other flowers. This is partly due to the size of the blossoms, but also to the appealing starburst arrangement of petals in the single-flowered forms. Another part of the sunflower's appeal is the dramatic contrast of orange petals and black centers (though this is not evident in the doubles).

Van Gogh was especially partial to the orange and black color combination, and our arrangement is inspired by this sensational color theme.

The bold graphics of *Vase with Twelve Sunflowers* allow it to succeed on its own, but the painting also offers ample inspiration for a gorgeous bouquet of flowers that will enhance any setting.

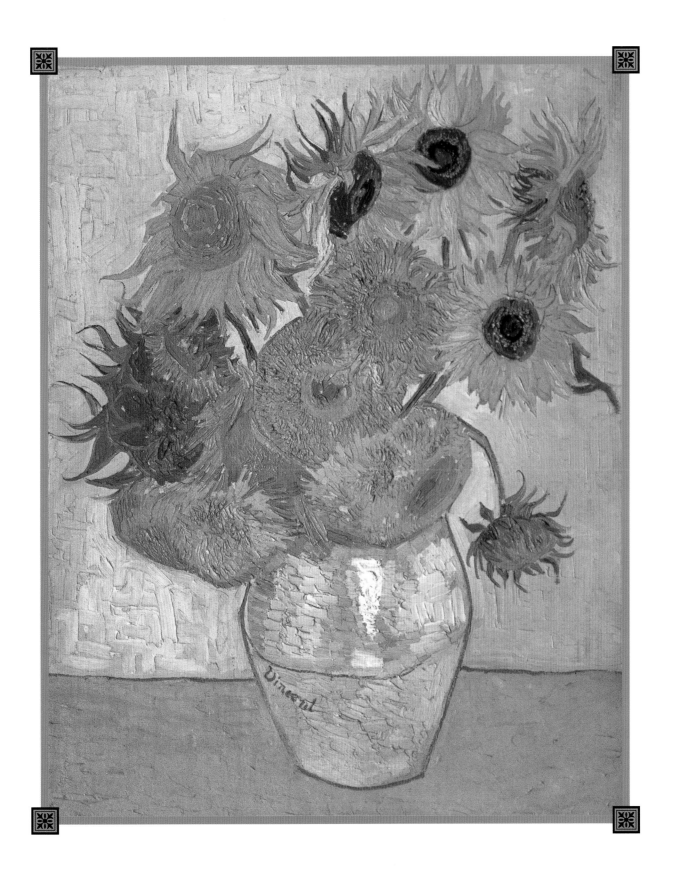

The Arrangements
59

*N*othing is more evocative of a fresh country feeling than annual sunflowers, so our arrangement makes use of a mass of them from the cutting garden at Cedaridge Farm, with an antique quilt for a background. The beauty of sunflowers is that an appealing design can be made with one, twelve, or twenty flowers in a vase with little or no fill or accent material, especially if you choose varieties with conspicuous black centers. Few other flowers (roses, irises, and peonies are obvious exceptions) can stand alone in a vase and make such a dramatic statement.

Use the yellow and orange sunflowers to illuminate dark corners or to further enliven brightly lit locations, as the cheerful, summery colors seem to grab all the available sunlight and hand it right back to you.

Making the Arrangement

1. Place the liner bucket inside the decorative bucket and fill half full with tepid water. Crumple the chicken wire and place inside bucket.

2. Begin with the shorter-stemmed sunflowers, guiding them through the spaces in the crumpled dome of chicken wire.

3. Next, add the sunflowers with longer stems, placing them behind the shorter stems.

4. Finish the design by adding the dill and anise, placing them at random throughout the design so that they produce a natural look.

5. Move the arrangement to the desired location. Top off the liner bucket with tepid water. Check the water level twice a day, adding as needed, since sunflowers require a great amount of water to stay fresh.

Overall Dimensions
40" tall, 24" wide

Materials
- 1 old-fashioned wooden bucket
- 1 waterproof 1-gallon bucket to use as a liner
- Chicken wire
- 12 medium-to-large sunflowers, 36" to 40" stems
- 8 sunflowers, 12" to 15" stems
- 12 stems of dill, 30" stems
- 5 to 7 stems of anise, 30" stems

Conditioning
Place all the cut flowers in a bucket of warm water immediately after cutting. Place the sunflowers in as deep a bucket as possible with water up to the flower head. Place in a cool location for 24 hours before arranging.

Still Life with Flowers

Paul Gauguin

Oil on canvas; 1881; National Gallery, Oslo, Norway

After coming under the spell of the early Impressionists in France, Gauguin moved to Tahiti, where he spent the happiest years of his life painting exotic fruits, foliage, and flowers, and it is for those motifs that he is best known. *Still Life with Flowers* was completed while Gaugin still lived in Paris, on the rue Carcel. Though the painting shows what appears to be a bowl of roses, the pale blues and pinks are actually much more reminiscent of the pastel asters known as China asters, which are annuals and much larger-flowered than perennial asters.

Although asters mix well with other flowers, the softness of the petal colors is so appealing that it is tempting to display them solo in a mass arrangement, especially when several of their different flower forms can be included. When cutting asters for a mass display, either use the plant cut at its base or uproot the entire plant. The flower cluster can then be allowed to fan out as a loose bouquet or it can be gathered in, with the flowers bunched together for a greater density of color. The colorful arrangement we've created with an abundance of asters possesses the same exuberance as the flowers in Gauguin's comfortable apartment.

Note the beauty of the patterned tablecloth in Gauguin's painting; the composition would be weakened if the arrangement were placed on a bare table, like so many of the arrangements painted by the Impressionists. The exquisite table linens and the elegance of the crystal bowl, coupled with the frilly flowers, help give Gauguin's painting its deep richness of texture.

Asters belong to the daisy family (Compositae) and they are among the most satisfying flowers to arrange because their petals take so many forms. They may be sharply pointed to form a spiky sunburst, curled like the feathers of an ostrich plume, or arranged in a single row like a true daisy. Moreover, the flower colors are soft and sensuous, and include creamy yellows, a range of reddish tones from pale pink to crimson, and a full spectrum of blues from powder blue to indigo. The annual asters used here are easily grown from seed sown directly into the garden. Expect them to flower in midsummer. Our design uses several different flower forms in a romantic arrangement set against a lace curtain in our sunroom. We've scrunched the tablecloth to give the design a pleasing, informal look, and laid a few extra flowers to the side of the arrangement for an added casual touch.

Making the Arrangement

1. Fill the large crystal bowl half full of tepid water. Crumple the chicken wire into a ball that will fit comfortably into the dish. Secure to the inside of the bowl with florist's tape.

2. Begin constructing the arrangement with the main material. Place the 'Perfection' and cactus-flowered asters securely into the holes of the chicken wire. Be careful to create a good balance of flowers from front to back and side to side to prevent the wire being tilted out of place.

3. Next add the pompon asters randomly throughout the design.

4. Complete the design by adding the wild white asters.

5. Position the smaller bowl in the location where the arrangement is to be viewed, and place the floral arrangement on top. Fill the container with water to just below the rim.

Overall Dimensions
28" tall, 30" wide

Materials
- 1 scallop-edge crystal bowl, 15" diameter, 12" tall
- 1 crystal bowl (turned upside down to form a pedestal), 8" diameter, 4" tall
- 1 piece of chicken wire 12" by 12"
- Florist's tape

MAIN MATERIAL
- 6 to 8 stems of bright red asters (split between double-flowered 'Perfection' and quilled-petaled cactus-flowered types)
- 2 to 3 stems of bright pink asters (split between 'Perfection' and cactus-flowered types)
- 1 or 2 stems of purple asters (split between 'Perfection' and cactus-flowered types)
- 1 stem each of small red, lavender, and pale pink pompon asters

FILL MATERIAL
- 2 to 3 stems of wild white asters

Conditioning
Remove the lower leaves from the stems and place them in a bucket of warm water up to the flower heads. Place in a cool, dark area for 24 hours before arranging.

The Blue Vase

Paul Cézanne

Oil on canvas; 1883–87; Musée d'Orsay, Paris

In Cézanne's painting *The Blue Vase*, the plants used are not readily identifiable, except for the conspicuous blue Dutch irises that crown the arrangement and echo the color of the vase. To name a floral design by the color of the vase is interesting, but not surprising when considering the work of an artist famous for powerful color associations. He had a fondness for green, which is evident not only in his numerous paintings of the countryside around Aix-en-Provence, but also in floral still lifes using the greens of foliage contrasts. This composition has very strong structural elements that make it a striking arrangement to imitate, not only in the tall, elegant lines of the vase and its scalloped edge but in the echo of the blue Dutch irises with their radiating petals. Tendrils of vines twist off into thin air.

The setting for the original arrangement is a corner of Cézanne's studio, and the flowers were undoubtedly gathered from his garden. Though Dutch irises are grown from bulbs planted in autumn and readily come back each year in areas with mild winters, they do not always overwinter for a second season in northern gardens and therefore may need replanting every year. Botanically known as *Iris × hollandica*, the Dutch iris is the result of hybridization among several

European species. In addition to shades of blue, its colors include white, yellow, and an unusual bronze.

The style of the arrangement is lush but simple, and there is a similarity between this arrangement and Cézanne's *Vase of Tulips* (see page 51). Both have a Japanese look about them, and both use fruit to link the bouquet to its location.

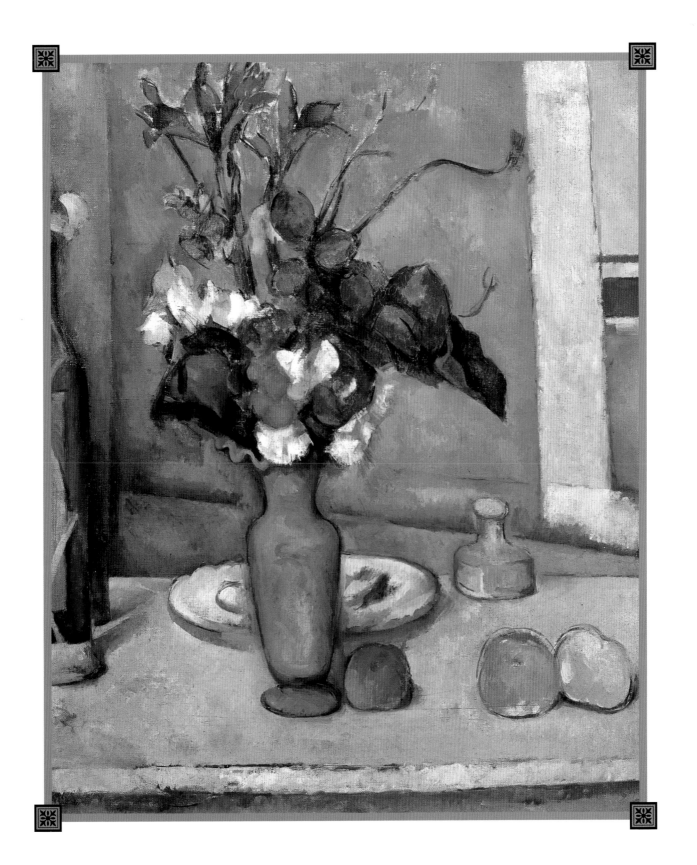

The use of the Dutch iris—a late spring flower—provides a clue to some of the other floral components, and so we have created an arrangement that captures the joyful spirit of the painting and replicates its flower forms and colors as closely as possible. We have used peonies and sweet Williams to produce the splashes of red, and more Dutch irises (in white and yellow) for the other important colors. To emulate the strong green leaves used in the arrangement we chose broad, pointed hydrangea leaves.

Making the Arrangement

1. Fill the container half full of warm water.

2. Begin the arrangement with fill material, placing the hydrangea leaves close to (but not resting on) the neck of the vase. Allow 1 set of leaves to extend far to the right of the container, with the 2 other stems creating a unifying mass at the center of the design. Allow the stems to cross over each other within the vase and rest against the opposite side of the container. This will create a network for the other stems to rest against, thus holding them in position.

3. Tuck the sweet Williams into the back left of the design, slightly above the hydrangea leaves.

4. Position the honeysuckle so that the vine extends above and beyond the center of the design.

5. Add the main material, allowing the stems to stand straight; the longer-stemmed blue and white irises will be taller; the shorter-stemmed yellow will be closer to the container.

6. Complete the design by adding the accent flowers. Add the scarlet peonies directly in front of the design so that they touch the edge of the container. Tuck the white irises behind the peonies.

7. Place the finished arrangement on a table or bureau and top off with tepid water. Add 'Gala' apples or 'Elberta' peaches.

Overall Dimensions
34" tall, 10" wide

Materials
• 1 tall, slender, gray-blue vase, 14" tall, 6" at its widest point, with a 4"-diameter mouth

MAIN MATERIAL
• 2 medium blue Dutch irises, 30" stems
• 3 deep blue Dutch irises, 30" stems
• 1 yellow Dutch iris, 30" stem
• 2 white Dutch irises, 18" stems

FILL MATERIAL
• 3 branches hydrangeas with broad leaves, 15" stems
• 2 or 3 deep burgundy sweet Williams, 20" stems
• 1 branch honeysuckle vine with curved leaflets

ACCENT MATERIAL
• 2 scarlet 'Bowl of Beauty' peonies, 15" stems
• 'Gala' apples or 'Elberta' peaches (optional)

Conditioning
Place the Dutch irises, sweet Williams, peonies, and hydrangea leaves in a bucket half filled with warm water immediately after cutting. If the flowers are purchased from the florist, make a fresh cut on each stem before placing in warm water. Allow to stand in a cool area for 24 hours before starting the arrangement.

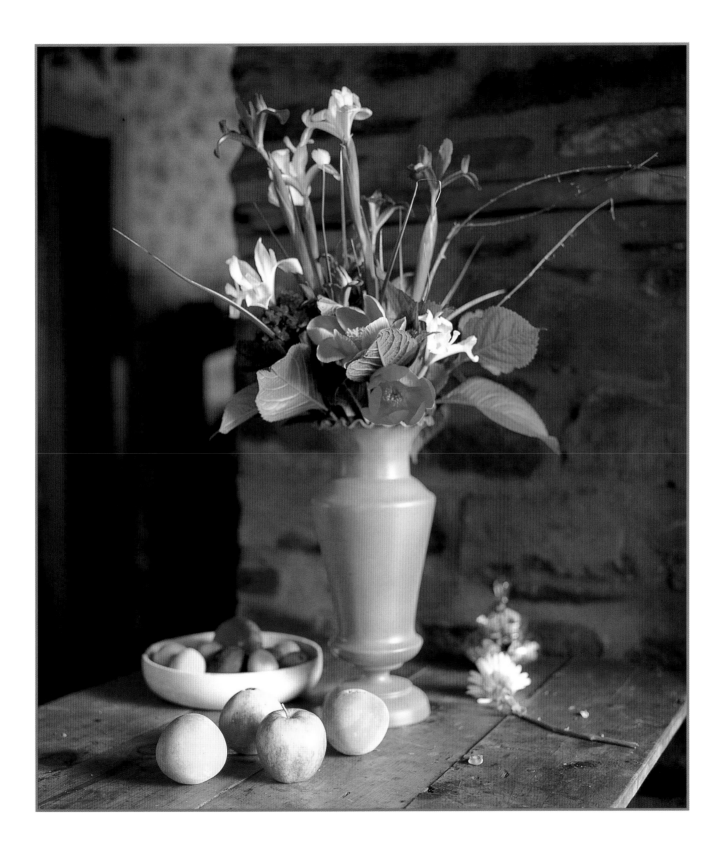

The Altar and the Shrine

Childe Hassam

Watercolor on paper; 1892; Pfeil Collection, New York

Shirley poppies in clear glass vases on a mantel—the altar—are the principal floral elements in this indoor composition that shows a detail of Celia Thaxter's parlor—the shrine—on Appledore Island, off the coast of Maine. Small end tables are also crowded with vases of flowers freshly cut from the garden. The low angle emphasizes the delicate faces of the poppies and provides a clear view of the glittering vases.

Hassam and his wife began visiting Appledore Island in 1888, and over three decades, until 1916, Hassam spent most of his summers at the resort hotel that faced Thaxter's small cottage and fenced cutting garden. The garden—and Thaxter's floral arrangements—became Hassam's favorite motifs.

Celia Thaxter expressed her adoration of flowers like few others, and yet she was not an arranger in the manner of Constance Spry, with her rules of design; instead, Thaxter's bouquets look effortlessly simple and "unarranged."

Indeed, she avoided placing different colors in the same container. Rather, she would group the same color tones of the same flowers in mostly clear glass containers and use the combined effect of multiple groupings to fill rooms with beautiful color harmonies. Often she created a hundred small bouquets and worked for several hours to position them for the effect she wanted. Filling a corner table or bureau top with a profusion of flowers is a delightful approach to arranging, and worthy of imitation. The secret of Thaxter's unique and beautiful style, however, is the concept of arranging shades of flowers in a single family from light to dark.

In our interpretation of the arrangement, we show that the idea of collecting the same type of flowers in various vases can be expanded to include flowers with similar shapes but of different families. Here, we chose to use pale pink evening primroses in company with annual poppies because we had no pink poppies and because the primroses are similar to poppies in appearance. Consider this type of collective arrangement with any flower that has an unusually wide color range, like zinnias and dahlias.

Any area where there are surfaces of varying heights, such as side tables, coffee tables, and mantels, makes a lovely setting for this type of grouping.

Making the Arrangement

1. Gather together 24 glass jars. These can range from small to large, but it is best to work with a range of similar sizes, as shown in the photograph. Fill each container three-quarters full of warm water.

2. Before beginning to arrange the flowers, place the glass containers in the location where they are to be viewed (poppy petals are fragile and will drop if roughly handled, so it is better to create the arrangement in its final location).

3. Begin placing the flowers by color, beginning at one side and working to the opposite side, beginning with the palest colors and graduating to the deepest colors at the opposite side. If the stems must be recut to adjust to a desired height, submerge again in hot water to prevent the scab formation.

Overall Dimensions
12" tall, 36" wide

Materials
- 24 clear glass containers in various sizes
- 6 pale pink evening primroses, 12" stems
- 6 pale orange poppies, 12" stems
- 6 scarlet poppies, 12" stems
- 6 crimson poppies, 12" stems

Conditioning
Poppies exude a milky sap that hardens and creates a scab, in the flower's attempt to hold in moisture. Unfortunately, this scab prevents any further intake of water from a vase and the flower soon wilts. Therefore, after they are picked, poppies must be plunged immediately into very hot water to prevent the scar tissue from forming. When cutting from the garden, carry a bucket of very warm water and plunge the stem into it the instant it is cut. Hold in a cool place for 24 hours before arranging the flowers into vases.

The Terrace

Carol Westcott

Oil on masonite; 1994; private collection

In Carol Westcott's painting of potted plants on a balustrade in a formal New England garden, it is the cherub statue we find so appealing because of the romantic touch and the definite Italian accent it adds to the landscape. The balustrade in the painting especially appealed to the artist when she decided to render the garden in oils because it recalled paintings of balustraded gardens featuring citrus trees in pots done by John Singer Sargent in Italy. The setting for Westcott's painting is her sister's garden in Provincetown, Massachusetts. Most of the flowers are tuberous begonias, which reach peak bloom in summer. Other favorite flowers of the artist are sunflowers, daisies, lilacs, and wisteria.

The sedate space in the foreground, with its ornate balustrade and cherub fountain, is in sharp contrast to the exuberance of the verdant background, creating a symbolic balance between the well-ordered world of civilization and the chaos of the wilderness. Presenting the potted flowers and plants in containers of varying shapes and sizes avoids the danger of monotony in the display, and the potted plants themselves provide a link between the manmade elements in the garden and the untamed greenery beyond the balustrade.

The complex subject—two distinct styles of a lush garden with all its nuances of color, sunlight, and shadow—is made cohesive by the arrangement of potted plants, while the painter's translucent brush strokes bring the composition to life, evoking the joyous feeling of a sunny day in a sheltered, intimate space.

*D*ecorating a small porch, a balcony, or even a back door with a few colorful containers and bright flowers adds considerable charm to any home, especially if the container plantings can help to frame elements of a nearby garden. Decorating with potted plants offers a long-lived floral display, especially with the inclusion of plants noted for perpetual flowering, such as tuberous begonias, ivy-leaf geraniums, and 'New Guinea' impatiens, which have the bonus of ornamental leaves and extra-large flowers. Maintenance is easy with these flowering plants: you need do nothing more than water them whenever the soil surface feels dry, remove spent blossoms, and feed every two weeks with a liquid fertilizer.

In re-creating the balcony scene in the painting, we have chosen not to use the cherub fountain, though it is a popular form of ornamentation that can be purchased inexpensively from outlets that sell concrete garden ornaments.

Making the Arrangement

1. Transplant each impatiens plant into its own pot.

2. Transplant all 4 begonias into 1 pot.

3. Put the coleus, nasturtiums, and ivy-leaf geranium together in 1 pot. Place the coleus in the middle, then the nasturtiums and geranium to the sides so that they cascade over the rim of the pot.

4. After planting the containers, place them on a balustrade, low table, porch step, or wide windowsill. Group similar colors together using the brightest colors at the center of the design. Place trays beneath the pots to collect water runoff.

Overall Dimensions
30" tall, 6' wide

Materials
- 4 decorative pots in a mixture of styles and sizes
- 2 hot pink 'New Guinea' impatiens
- 4 orange 'Nonstop' begonias
- 4 'Wizard' coleus in mixed colors
- 2 nasturtiums
- 1 ivy-leaf geranium

Conditioning
Prepare containers with a peat-based potting soil, mixing equal amounts of peat with sand and screened garden topsoil. Water to keep uniformly moist, remove spent blossoms to encourage continuous bloom, and fertilize with liquid plant food every two weeks at time of watering. If coleus produces flower spikes, remove them to encourage a bushier, longer-lasting plant. Make sure the drainage hole in each pot has some broken crockery or coarse gravel over it to avoid clogging. These plants do best in a lightly shaded location, but will tolerate full sun if watered regularly.

Vase with Poppies, Daisies, Cornflowers, and Peonies

Vincent van Gogh

Oil on canvas; 1886; Kroller-Muller Museum, Otterlo, Holland

Painted while van Gogh was living in the Montmartre district of Paris, this marvelous arrangement was an early experiment with bright colors. Prior to this period, his work was characterized by somber colors, especially earth tones. Before his Parisian floral still lifes, van Gogh, who had abandoned a career as an evangelist to the poor, had painted genre studies of working people and farmers. In Paris, however, van Gogh was strongly influenced by the Impressionist painters. He was especially taken with the art of Monet and Renoir, whom he admired above all other modern painters. Indeed, Renoir lived just a few streets away from van Gogh, and though Renoir could not ever recall meeting him, Renoir's favorite model, Gabrielle, remembered seeing van Gogh in local restaurants and markets. Neither was van Gogh able to make contact with Monet, though he saw much of Monet's work at local exhibitions and through his brother, Theo, an art dealer who valued Monet as an important client.

The arrangement featured in *Vase with Poppies, Daisies, Cornflowers, and Peonies* has many more components than are evident at first glance, and we have tried to include in our arrangement all the flowers identifiable in the painting. Most prominent are white ox-eye daisies, yellow mar-

guerite daisies, red corn poppies, and blue cornflowers in the vase, plus pink peonies strewn around the base. Van Gogh's still lifes during this period are so dramatic and so different from anything he painted before that they stand out like beacons in his artistic development, displaying the brightness and boldness typical of his future work, and for which he remains famous today.

*W*hat a striking image of country flowers this is! Next to his sunflowers and irises, this is probably van Gogh's most endearing bouquet.

In this arrangement several large bunches of flowers achieve a dramatic impact that is possible only with the fierce color contrasts of different flowers in generous groupings. The use of so many white daisies is dazzling, especially against the blood red poppies. Our arrangement follows the painting closely, using the same dominant flowers—crimson poppies, blue cornflowers, pink peonies, and white ox-eye daisies.

Making the Arrangement

1. Fill the container half full of tepid water.

2. Place the poppies (reserving a few stems for the table) on the right side of the container in a bold bunch.

3. Add the white daisies on the left side. Fluff them together with the poppies to create a natural look.

4. Position the cornflowers to the rear of the poppies, fanning them apart so that they are visible.

5. Place the yellow daisies near the white daisies for an intense color impact that suggests dazzling light.

6. Place the finished arrangement in the location you've chosen for them. They look especially lovely in a dark or shaded corner, where the bright colors can shine like jewels.

7. Lay the peonies and remaining poppies on the table. Top off the container with tepid water.

Overall Dimensions
30" tall, 15" wide

Materials
• Painted metal canister, 12" tall, 4" diameter

MAIN MATERIAL
• 20 red corn poppies, 18" stems
• 20 white ox-eye daisies, 18" stems
• 10 blue cornflowers, 18" stems

FILL MATERIAL
• 5 yellow marguerite daisies, 10" stems

ACCENT MATERIAL
• 5 pink, half-open peonies, 6" stems

Conditioning
Once cut, the poppies must be dipped immediately into hot water to prevent a scab from forming over the cut and depriving the stem of water. Remove the poppies from the hot water and place them, together with the daisies, cornflowers, and peonies, in warm water. Place all in a cool location for at least 24 hours before arranging.

Bouquet of Yellow Dahlias

Paul Cézanne

Oil on canvas; circa 1873; Musée d'Orsay, Paris

Dahlias appealed to the Impressionists for the same reason that zinnias, chrysanthemums, and asters did—the daisylike form of their flowers. Although dahlias come in a variety of flower shapes and sizes, it is the common bedding type that the Impressionists preferred to paint. Horticulturally, dahlias are divided into two main groups—bedding-type dahlias, with daisylike flowers that can be grown from seed, and tuberous dahlias that are grown from sausage-shaped roots.

Some of the tuberous dahlias can be extremely large-flowered, growing as big as dinner plates. Those with rounded petals are called "formal decorative" while those with quilled petals are called "cactus-flowered." A smaller-flowered series with a contrasting frill around the petal center (formed by a second row of petals) is known as "collarette" dahlias. Dahlias are particularly good flowers for arrangements because they are available year-round from florists, and are also easy to grow in the garden; we know of no area in North America where they cannot be grown.

Dahlias also come in a range of colors, from white to pink to deep maroon and through the oranges to the yellow of the painting's title. Though Cézanne's work refers specifically to yellow

dahlias, this is somewhat misleading, as other colors are used in the arrangement, making it a mix of warm colors.

The blue and white porcelain vase shows Cézanne's appreciation of Japanese art, though the explosion of wayside flowers—such as goldenrod—produces a floral effect more reminiscent of the Flemish still life painters of the previous century.

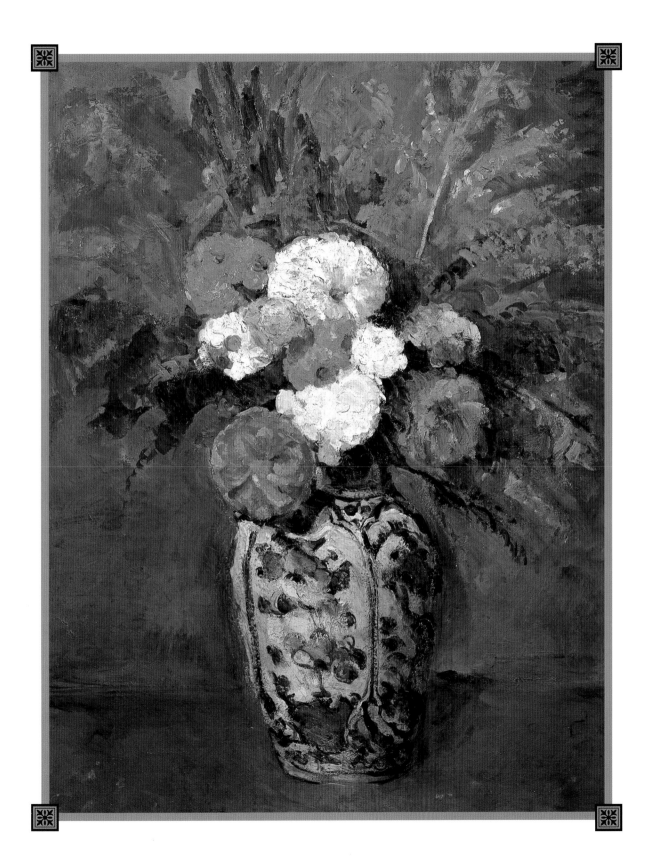

In our arrangement inspired by Cézanne's masterly still life, we have not confined ourselves to the bedding dahlias, but have used a representative selection of both bedding and tuberous types in a dramatic hot color harmony.

Though it's fun to make arrangements using one particular type of dahlia—or even one color—accented by other garden plants such as lilies and gladiolus, we have chosen to show how splendid an impact can be made with a wide range of colors and sizes, accented by the starry white flower clusters of garlic chives from our herb garden and the feathery flower plumes of goldenrod gathered from our meadow.

Making the Arrangement

1. Fill the container three-quarters full of tepid water.

2. Begin arranging with the main material, adding the dahlias in groups of colors. Place all the yellows together, then add the orange tones next to them.

3. Continue by adding fill material—the white bedding dahlias and the red collarette dahlias—randomly throughout the design.

4. Add the accent flowers in groups around the edges, allowing them to spill out beyond the general outline of the design. Take care not to make too tight an arrangement—the dahlias should appear as if they are exploding into the air and falling away from the container in a burst of riotous color.

5. Place the finished arrangement in the location where it is to be viewed. Top off the container with tepid water.

Dimensions
30" tall, 30" wide

Materials
• 1 old-fashioned bowl and pitcher set in vibrant blue

MAIN MATERIAL
• 4 bright orange formal decorative dahlias, 30" stems
• 3 yellow formal decorative dahlias, 30" stems
• 5 pink cactus-flowered dahlias, 24" stems
• 2 to 3 red formal decorative dahlias, 24" stems

FILL MATERIAL
• 5 to 9 stems of small white bedding dahlias
• 3 to 4 stems of red collarette dahlias

ACCENT MATERIAL
• 3 to 4 stems of wild goldenrod, 15" to 18" stems
• 20 stems of flowering garlic chives, 15" to 18" stems

Conditioning
Remove all the leaves from the bottom three-quarters of the stems. Immediately after cutting place all the dahlias in warm water up to the bottom of the flower head. Leave in a cool, dark place for at least 24 hours before arranging.

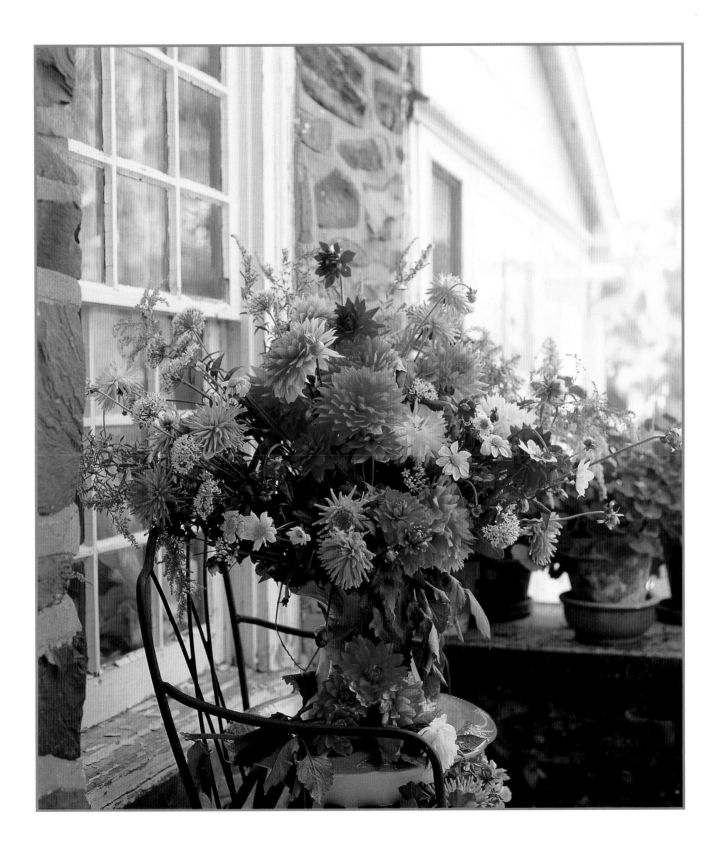

Spring Flowers

Claude Monet

Oil on canvas; 1864; Cleveland Museum of Art

Claude Monet and Píerre-Auguste Renoir were lifelong friends. They met as students at the Gleyre Studio in Paris, rooming together and traveling the countryside in search of motifs, often painting the same scene side by side and challenging each other to render the best impression. *Spring Flowers* was painted during a visit the two made to an estate near Paris as weekend guests of an important art patron, Ernest Hoschedé. While Renoir busied himself painting *Spring Bouquet* (see page 43), Monet selected his own material for this glorious still life.

Monet's arrangement combines Rembrandt tulips and lilacs, which bloom in early spring, with peonies and baby blue eyes, which bloom in late spring. It is possible that the peonies and baby blue eyes were forced in a greenhouse, making them available at the same time as the Rembrandt tulips and lilacs. As in Renoir's *Spring Bouquet*, which also features pink peonies, the pink pigments have faded over the years, and today the effect is darker and less colorful than it was originally.

Other plants used in Monet's arrangement include a red geranium, some English ivy, a sprig of pink and white weigela, Siberian wallflowers, potted pink hydrangeas, and white snowball

viburnum (*Viburnum plicatum*). Also important to the appeal of the painting are the rich textures produced from contrasting brown wicker baskets with a terra-cotta clay pot and the gray stone balustrade on which the display rests.

*R*emember that an arrangement does not have to consist of only cut flowers—it can also be a combination of cuts and potted plants, as in this early Monet still life. We used peonies and other flowers from our garden that bloom at the same time to create this beautiful pink, blue, and white triadic color harmony of the original.

This outstanding display is perfect for a special occasion, but be sure to consider how long the flowers laid beside pots for accent will be out of water. Spraying at intervals with a fine mist and avoiding direct sunlight can keep them fresh all day.

Making the Arrangement

1. Choose the location for the finished design, allowing for a multilevel creation. In this case we used the balustrade and top tread of a flight of stone steps leading up to the back door of our kitchen. A wooden box, rustic bench, or small table will give the same effect.

2. Gather together the potted geraniums, hydrangea, and browallia, placing some on the top level and some to the sides of the bottom level.

3. Insert the watertight container in the flower basket. Place 10 stems of viburnum in the basket to form a tight group.

4. Add the pink lilacs to the front section of the basket.

5. Position the honeysuckle in the left corner of the basket, allowing it to stand erect and connect visually to the top level.

6. Fill the glass container half full with water and add the Siberian wallflowers. Position the glass container directly beside the basket.

7. Carefully lay the blackberry blossoms in the flat basket, and position it next to the blue browallia.

8. Lay the remaining stems of viburnum and the pink peonies on the bottom level.

9. Lay the tulip to one side and the 'Bowl of Beauty' peonies on top of the other peonies, making sure the yellow center is facing forward. Add the white peony for accent.

Overall Dimensions
40" tall, 40" wide

Materials
- 1 deep flower basket with added watertight liner
- 1 shallow, flat gathering basket
- 1 slender glass container, 6" tall, with a 2"-diameter mouth
- 6 terra-cotta clay pots

MAIN MATERIAL
- 1 potted pink hydrangea
- 6 to 8 hybrid pink lilacs, 10" to 12" stems
- 3 deep pink peonies (2 in full flower, 1 as a half-open bud), 6" to 8" stems
- 4 bright red 'Bowl of Beauty' peonies, 6" to 8" stems
- 1 white peony, 6" to 8" stem

FILL MATERIAL
- 15 white viburnums, 12" stems
- 5 pots pink, red, and variegated geraniums (12" pots)
- 1 pot blue browallia (12" pot)
- 5 white blackberry blossoms, 6" to 8" stems

ACCENT MATERIAL
- 1 pink and yellow 'Gold Flame' honeysuckle, 15" stem
- 6 orange Siberian wallflowers, 8" stems
- 1 bright red tulip, 6" stem

Conditioning
Place all the stems in a bucket of warm water immediately upon cutting. Allow to stand for 24 hours in a cool area. Remove any spent blossoms or discolored leaves from potted plants. Water well.

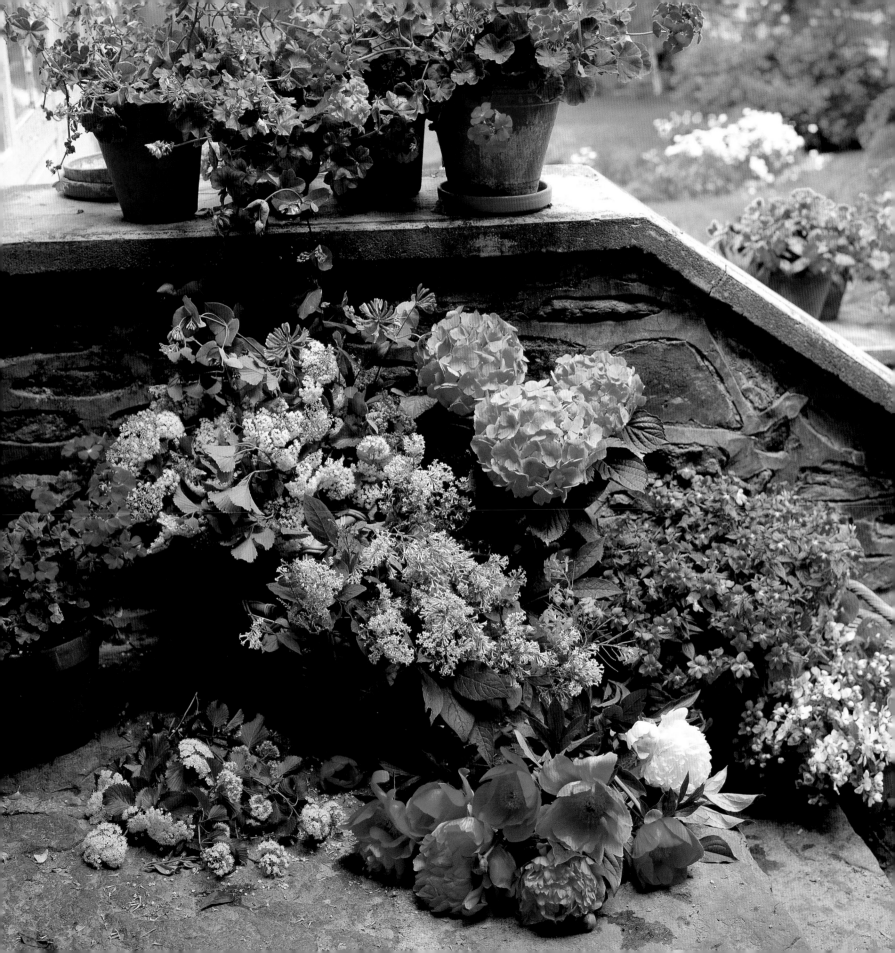

Roses in a Vase

Pierre-Auguste Renoir

Oil on canvas; 1876; Musée d'Orsay, Paris

If the sunflower belongs to van Gogh and the water lily to Monet, then the rose belongs to Renoir. No one could capture the allure and swirling petal construction of these glorious flowers better than Renoir, though the rose was a favorite motif for many of the Impressionist painters. The first ever-blooming, large-flowered hybrid tea, 'La France', was introduced in 1867, and it became a favorite rose to paint because of its high-centered, vaselike shape. However, the Impressionists also liked old-fashioned varieties with cup-shaped blooms and swirling petals. Actually, the shape of a rose can change dramatically from day to day—from a tightly folded urn shape in its mature bud stage to a fully open cup shape with petals ready to fall away at the slightest touch and a crown of powdery yellow stamens exposed at the center of each blossom.

Renoir painted roses more than any other flower, not only as still lifes in his studio but also outdoors in gardens and as embellishments to his figure paintings of women, who wore them as corsages, to adorn their hair, and even around the brims of their hats. Renoir's later works, especially those completed during his occupancy of Les Collettes, are especially vibrant as a result of their "rosy glow," an effect that came as a result of using roses to practice capturing elusive colors such as flesh tones.

Before he moved to Les Collettes, one of the gardens that had a profound influence on Renoir was a property he rented after he was married, the Château des Brouillards. The garden there was in a state of organized chaos, on the verge of reverting to wilderness. Roses grew phenomenally, especially climbers that would hook their thorns onto every kind of support, even up into mature trees, draping the atmosphere with an avalanche of pink and red blossoms.

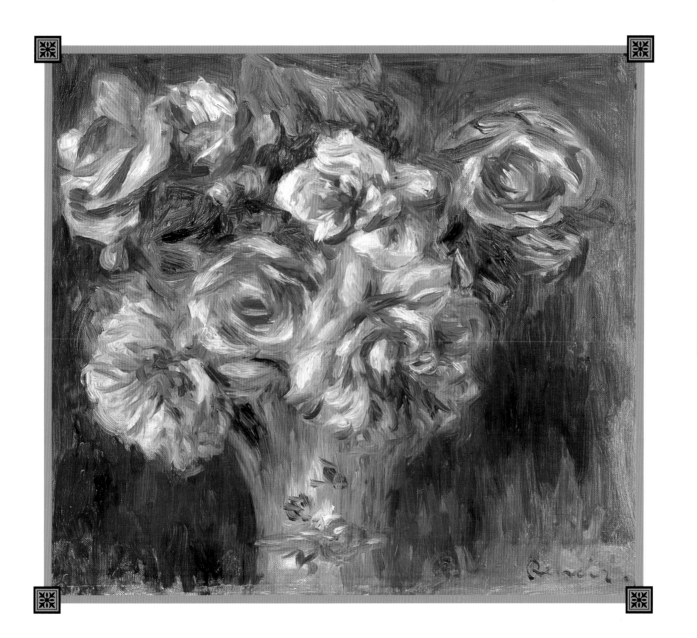

*N*o other flower is more highly favored for floral displays than the rose, especially old-fashioned varieties with tightly packed layers of petals in swirling patterns and a fruity fragrance. When properly conditioned, a rose has a long vase life, and it is an easy flower to dry for winter bouquets.

For this arrangement we selected a range of colors to present a polychromatic color harmony, and chose a blue vase similar to the one in the painting. The setting is Renoir's indoor studio, located on the ground floor of the main house at Les Collettes, and the arrangement uses roses picked fresh from the formal rose garden. Light floods the room from a large picture window that looks out onto the garden. Renoir's painting paraphernalia, his easel, and his wheelchair are part of the furnishings and ornamentation of the room.

Making the Arrangement

1. Fill the container half full of tepid water and remove any leaves that of would fall below the waterline.

2. Cut the first roses so that their blooms will hover just above the rim of the container and place them around the edges.

3. Continue to add roses, gradually increasing the length of the stems so that the arrangement builds in height toward the center. Take care not to make stems the same length; allow a few roses to be low and others to tower above. Let your own eye guide you in placing colors in a pleasing fashion.

4. Place the arrangement in a location away from direct sunlight. If possible, move to a cool location at night. Roses consume a great deal of water, so check the level on a daily basis. For longer vase life change the water every other day and ensure that no leaves come in contact with the water, or they will putrefy.

Overall Dimensions
16" tall, 12 " wide

Materials
- 1 tall, slender container, 14" tall, 4" wide, with a 4"-diameter mouth
- 15 mature hybrid tea roses in assorted colors, 24" stems

Conditioning
Roses are the most versatile flowers for cutting. Their woody stems resist wilting if properly conditioned, the flowers lasting for up to two weeks. The flowers benefit from having their stems cut underwater, which prevents air bubbles from forming in the stem and blocking water intake. When cutting from the garden, take a bucket containing a few inches of warm water and plunge the stems below the waterline as soon as they are cut. Once inside the house, the stems must be cut again, preferably underwater. Cut with a sharp knife at an angle and place the blooms in a bucket of water. A floral preservative can be added to lengthen the display. Allow the roses to stand for 24 hours before arranging.

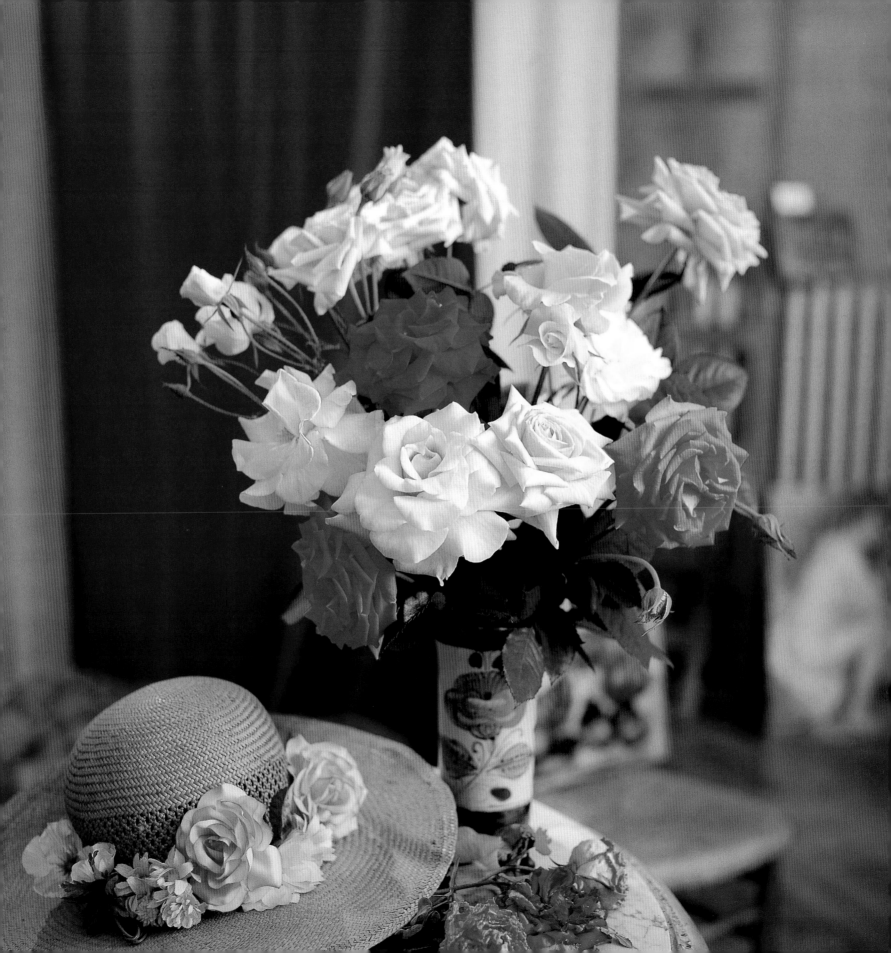

Clematis in a Crystal Vase

Édouard Manet

Oil on canvas; 1882; Musée d'Orsay, Paris

The arrangement shown in *Clematis in a Crystal Vase* is reminiscent of Japanese floral arrangements because of its zigzag axis, rakish placement of carnations, geometric glass vase, and low viewpoint. The creation of a dramatic and memorable floral display is often due to the striking differences in the flowers chosen for the composition. We especially like this still life of Manet's because common small-flowered carnations are partnered with a single blossom of a deep purple clematis. The star-shaped clematis at the center of the arrangement is undoubtedly a species known as *Clematis jackmanii*, developed by Jackman's, a leading British clematis nursery. This strong-growing, summer-flowering variety is still extremely popular today, though many other colors are available. In general, clematis are rich in all shades of blue and red, as well as white.

The carnations in the arrangement are a pale pink variety known as pinks, popular as a cottage garden flower because they grow low, dome-shaped plants and are highly fragrant. These differ greatly from florist carnations, which are generally larger-flowered and have a more rounded, hybridized flower form. Since clematis is rarely sold as a florist flower (it travels poorly when cut), Manet undoubtedly picked these flowers fresh from his own garden and plunged them straight into water. The white elements are indistinct, but appear to be white Dutch iris. Also, there seems to be a short irregular section of apple branch with a blossom, which giving the stems in the vase more substance.

Most important in a simple design such as this are the elements of structure and form. When using a crystal container the stems of the flowers are visible, and play a major role in the overall design. It seems clear that Manet intended for the thick stem of the apple branch to echo the thickness of the vase.

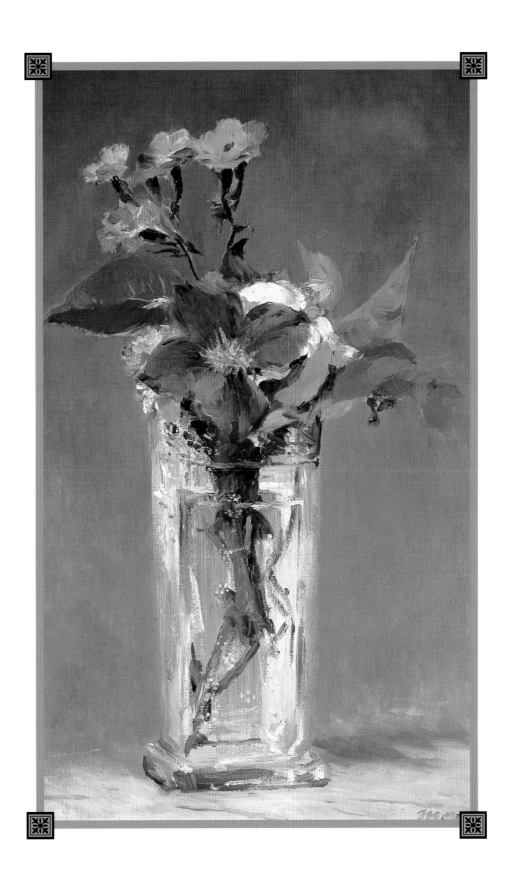

We have chosen to duplicate this carefully composed arrangement as closely as possible, placing it against a plain dark background to accentuate its beautiful lines and cool color harmony of blue, pink, and white. We have used a similar stubby apple branch to give substance to the design. The delicate pink carnations atop slender stems seem to leap out of the top of the arrangement, while the starlike clematis flower acts as an anchor while tying together the distinctly Japanese arrangement. Instead of the dark purple Jackman's clematis used by Monet, we have chosen a flower with a lighter color.

Making the Arrangement

1. Fill the vase three-quarters full of water. Give each stem a clean cut at an angle before placing it in the arrangement.

2. Begin arranging with the fill material, placing the apple branch in the center of the container and allowing it to lean toward the back.

3. Next, position the iris so that the stem follows the same line of the apple branch, allowing the head of the iris to lean on the rim of the container.

4. Position the clematis in front of the container, allowing the flower head to rest on the rim.

5. Position the carnations so that the stems follow the same line as the apple branch, projecting at an angle high into the sky.

6. Add the clematis leaves close to the rim of the container (make sure they reach down into the water).

7. Put the arrangement in a location with a dark background to emphasize the pink and blue color harmony. We have added an accessory (a gold ginseng tea container) to complement the Asian feeling of the painting.

Overall Dimensions
24" tall, 6" wide

Materials
- Thick crystal vase, 9" tall, 4½" wide

MAIN MATERIAL
- 1 blue, purple, or pink clematis, 4" to 6" stems
- 1 white iris (Iris × *hollandica* or I. *sibirica*), 15" stems

FILL MATERIAL
- 1 segment of apple or crab-apple branch, 24" length, with or without blooms
- 5 to 6 large clematis leaves

ACCENT MATERIAL
- 6 to 8 stems of pale pink carnations (*Dianthus caryophyllus*), 18" to 20" stems (avoid larger-flowered florist's carnations for this arrangement, as the smaller carnations have a more appealing presence)

Conditioning
Place the clematis flowers and leaves in warm water immediately after cutting. Remove 1" to 2" of bark from the cut end of the apple branch, then slit lengthwise to allow the most water absorption. Remove all the lower leaves from the carnations. Place all the flowers and apple branch in a small amount of water and leave in a cool area for 12 hours or overnight.

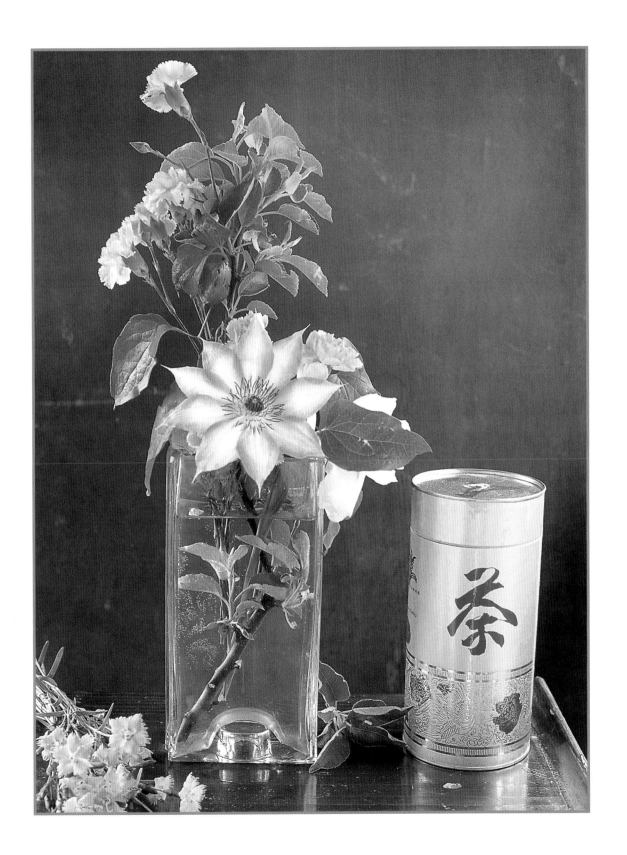

Bunch of White Peonies in a Vase on a Pedestal

Édouard Manet

Oil on canvas; circa 1880; Musée d'Orsay, Paris

Manet's painting of peonies has suffered a loss of color over the years; what appear to be mainly white peonies probably included some pink tones. Whatever the condition of the painting, it commands a prime position in the prestigious Orsay Museum in Paris, and it serves to underscore the immense attraction peonies had for the Impressionists. These luscious flowers are a dominant feature of many still life arrangements by Cézanne, Renoir, and van Gogh, while Monet adored peonies so much he grew literally hundreds of them as hedges around his vegetable plots.

An uplifting gardenialike fragrance and nostalgic old-fashioned charm make the peony one of the most desirable spring flowers for cutting. Although peonies are available in single and double forms, it is the robust double forms with many layers of petals that the Impressionists most liked to paint.

It is difficult to identify the shadowy flower clusters in the background of this work. Though they could be more peonies they look like trusses of rhododendron blooms. Certainly the combination of peonies, and rhododendrons—with their similar blooming time, compatible colors, and similar flower size—is a good one.

In this painting, Manet suggested a Japanese influence by his choice of container, but leaned toward the European liking for massed effect in the overall design. A peony blossom was seemingly plucked from the arrangement and laid beside a pile of spent peony petals to subtly link the arrangement with its location.

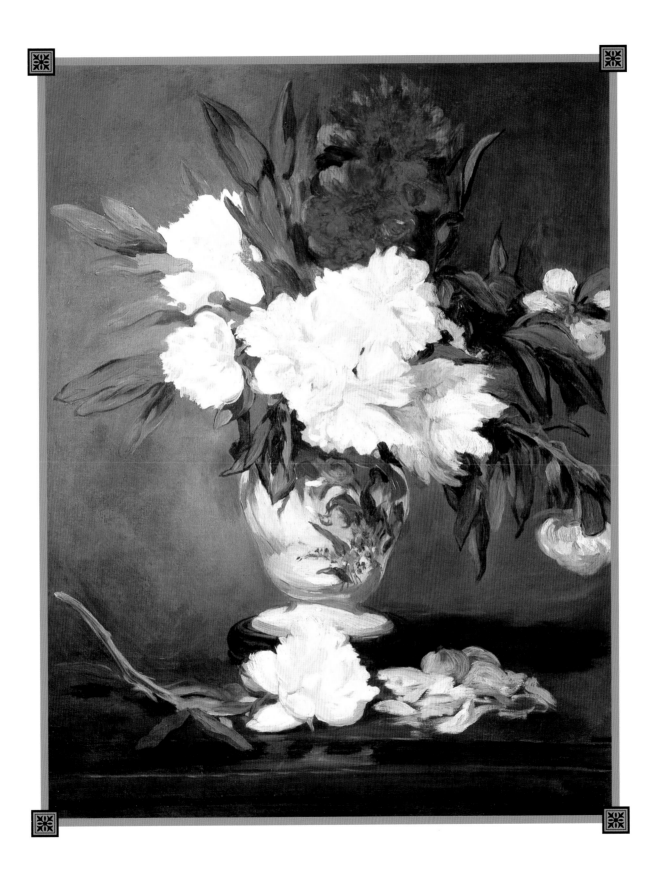

\mathcal{P}eonies and bearded irises—two chieftains of the perennial clan—bloom at the same time, in late spring. The two look so well together that we decided to create an arrangement with pink and white peonies, mixing in some blue bearded irises from our garden and a few Asiatic lilies as main material. Other spring flowers, including pink asters and ox-eye daisies, are used for fill. Accent material consists of fragrant red and pink sweet Williams. These blooms are all massed in one big bold arrangement, to be used indoors or outdoors. A cluster of porcelain chickens adds a touch of whimsy to the composition.

Making the Arrangement

1. Crumple the two pieces of chicken wire and insert into the two freezer containers, filling each container with tepid water. Insert these containers into the basket side-by-side, hidden from view.

2. Begin the arrangement with the pink peonies, then add the bearded irises and Asiatic lilies, positioning them to create the main flow of the design and pushing the stems through the chicken wire in either container.

3. Next, add the fill material, allowing the flowers to project past the main form into space.

4. Carefully tuck the accent material close to the peonies so the accents echo the colors of the main material.

5. Place the arrangement in its final location, preferably where it can be appreciated from all angles. Once in place, top off the container with tepid water.

Overall Dimensions
20" tall, 16" wide

Materials
- 1 large wicker basket, 14" long and 6" wide by 6" deep
- 2 quart-size freezer containers
- 2 6" squares of chicken wire

MAIN MATERIAL
- 1 large pink peony, 15" stems
- 2 large white peonies, 12" stems
- 4 deep blue bearded irises, 18" to 20" stems
- 2 deep chocolate bearded irises, 20" stems
- 2 stems of pink Asiatic lilies, 12" stems

FILL MATERIAL
- 2 to 3 stems pale pink asters, 20" stems
- 2 to 3 stems deep lavender asters, 10" to 12" stems
- 6 to 8 stems ox-eye daisies, 20" stems
- 8 to 10 stems of blue and white Virginia bluebells, 12" to 15" stems
- 5 to 7 stems of quince foliage

ACCENT MATERIAL
- 2 to 3 stems deep pink sweet Williams
- 2 to 3 stems deep red sweet Williams, 8" to 10" stems.

Conditioning
Strip leaves from the lower stems of the lilies and asters before conditioning. All flowers and quince foliage should be placed in warm water and held in a cool, dark place at least 24 hours before arranging.

Marguerites

Pierre-Auguste Renoir
Oil on canvas; 1905; private collection

The Impressionist painters had a particular liking for flowers with petals arranged in a daisy shape, especially those with a rich color range, such as dahlias and zinnias. These common garden flowers are extremely easy to grow and rewarded the painters with long-lasting color—until autumn frost brought an end to the garden display.

Renoir owned property in the south of France, where he had a sizable garden, and his still life arrangements tend to be composed of the common flowering plants that grew there. Indeed, when the sculptor Auguste Rodin visited the Renoirs and saw how beautiful their garden was, he inquired whether any rare or unusual flowers were among the plantings. Madame Renoir replied: "There are no rare flowers here—but marguerites next to the mimosa. My husband likes common or garden flowers."

Though the painting shown here is titled *Marguerites*, the flowers depicted are actually zinnias and African daisies. The true marguerite daisy, known botanically as *Chrysanthemum fruticosum*, is a shrubby plant available mostly in white and pink. When Renoir's paintings were assembled after his death many were untitled and had to be identified quickly for inventory purposes. Renoir's will stipulated that the paintings stored in his house near Nice were to be divided among his three sons. When the local police chief was called in to administer the will he sometimes, in his haste and unconcern for botanical accuracy, applied inappropriate titles, even calling a painting of peaches "apples."

Whatever the official title of the painting, Renoir's sensational hot color grouping captures all the vibrance of a Mediterranean summer.

The
Arrangements
103

*S*ince the flowers in Renoir's painting are mostly zinnias in vibrant colors, we have made them the focus of our arrangement. The numerous varieties—from giant "dahlia-flowered" types to the diminutive 'Mexicana' cultivars—all offer long stems for cutting and a spectacular range of colors, including yellow, orange, red, purple, white, cream, and even green and bicolors.

Zinnias are most appropriate in informal country-style arrangements. Here, we have placed the bountiful gathering on a cutting table next to an old-fashioned stove in the kitchen, where a wall composed of weathered barn-siding creates a rustic background.

Making the Arrangement

1. Fill the pitcher three quarters full of tepid water.

2. Remove from the stems any leaves that may fall below the waterline.

3. Begin the arrangement with the fill material. Place each stem into the container, allowing it to rest against the inside of the container. Add each stem at a different angle to form a network of self-supporting stems. Position the 'Persian Carpet' zinnias around the outer edge of the design.

4. Next add the main material. Begin with the red zinnias, adding in a random manner; then add the pink, clustering them loosely toward the front center. Add the yellow and orange so that they are close to the yellow plumes of goldenrod.

5. Complete the design by adding touches of white from the ageratum and asters.

6. Place the arrangement in the location where it is to be viewed. Balance the power of the bouquet with an understated array of colorful vegetables and fruits, such as peppers, tomatoes, and apples with colors that echo the zinnias. Top off the container with water and check it daily as these flowers are heavy drinkers.

Overall Dimensions
24" tall, 15" wide

Materials
• 1 milk pitcher, 8" tall, 4" across at widest point

MAIN MATERIAL
• 6 to 8 bright red dahlia-flowered zinnias, 12" to 15" stems
• 3 to 4 hot-pink dahlia-flowered zinnias, 12" to 15" stems
• 2 to 4 canary yellow dahlia-flowered zinnias, 12" to 15" stems
• 1 or 2 bright orange dahlia-flowered zinnias, 12" to 15" stems

FILL MATERIAL
• 6 to 8 stems of red and gold 'Persian Carpet' zinnias (also known as 'Mexicana'), 12" to 14" stems
• 4 to 5 stems of wild goldenrod, 15" stems

ACCENT MATERIAL
• 6 to 8 stems of white hardy ageratum, 15" stems
• 2 to 3 stems wild white panicled aster, 12" stems

Conditioning
Carry a tall bucket containing a few inches of warm water into the garden when gathering zinnias. Plunge each stem immediately into the bucket. When finished, fill the bucket with warm water up to the head of the flowers. Place the bucket in a cool, dark place for at least 24 hours before arranging.

Vase of Irises with Yellow Background

Vincent van Gogh

Oil on canvas; 1889; Vincent van Gogh Museum, Amsterdam

The iris is a flower with so much drama in its form and color that a single blossom can fill a room with its beauty. The Impressionists liked the interesting flower heads of bearded irises, which have three broad petals (called "falls") sweeping down and three slender petals (called "standards") arching up. These painters also admired the vast color range of bearded irises and their spiky blue-green, sword-shaped leaves. Though the flowers are mainly blue, the color range includes white, yellow, orange, ginger, purple, red, pink, green, and even black, and many are bicolored. Most flowers have a conspicuous arrangement of powdery yellow or orange stamens—called a "beard"—on the lip of each falling petal.

The cottage garden where van Gogh found colonies of irises to paint during his stay at an asylum in Saint-Rémy is still there—the dark blue bearded irises flower in March among orange calendulas. Van Gogh painted these irises both outdoors in the cottage garden beyond the walls of the asylum, and then indoors as floral arrangements. He painted the arrangements twice, first in a bulbous yellow urn against a yellow background and then in a white pitcher against a pink background.

Van Gogh obviously arranged the stems himself, making them splay out in vases that many professional flower arrangers today might consider too small, but the proportions work surprisingly well, particularly when slender, sword-shaped iris leaves are used as fill.

The impact of van Gogh's painting and of the mass arrangement it inspired derives from the intense animation of the lines, endowing the blooms with quivering life, and from the contrast of blue and yellow, colors opposite each other on the color wheel.

This arrangement of deep violet-blue and purple irises is best positioned on a large buffet table or in a spacious foyer. It is so big and bold that it demands a large space for its majesty to be appreciated. The height of this arrangement is almost two and a half times the height of the container, but it is still well proportioned. This is because the round container, with its wide belly and small opening, allows the iris stems to fan out from the center of the design.

One bonus of bearded iris is that they pervade the air with a pleasant spicy fragrance when brought indoors. They are not long-lasting either as garden flowers or indoors in arrangements. Though each flower generally lasts no more than three days, each stem is studded with up to a dozen buds, which can prolong the flowering display.

Making the Arrangement

1. Crumple the chicken wire and place it inside the container, making sure it fits snugly against the sides. Give each stem a diagonal cut before placing into the arrangement.

2. Begin the arrangement by placing one deep purple iris directly in the center of the container to establish the height of the design.

3. Continue adding purple irises toward the edges, creating a fan effect.

4. Use the medium-blue irises together on one side and the light blues together on the other side.

5. Complete the design by inserting the leaves directly in front of the design and in the midsection.

6. Place the arrangement in a bright location, as blue tones tend to disappear in poor light. The dark tones of bearded irises can stain if the petals drop, so always protect the table with washable cloth (avoid white or light-colored tablecloths, as the stain can be permanent).

Overall Dimensions
30" tall, 24" wide

Materials
- 1 round ceramic container, 12" tall, 10" diameter at wides part, 4" at neck opening
- 18" × 8" square of chicken wire
- 10 deep blue bearded irises, 30" stems
- 4 deep purple bearded irises, 20" stems
- 3 pale blue irises, 18"stems
- 3 to 4 iris leaves, 30" length

Conditioning
Once the irises are cut or brought home from the market, place them in a bucket with several inches of warm water. Allow flowers to stand a few hours before arranging. Bearded irises normally have a short vase life and should not be relied upon to look fresh for more than a day or two. As old flowers fade they become wrinkled and should be removed to encourage new flower buds to open.

Chrysanthemums

Claude Monet

Oil on canvas; 1878; Musée d'Orsay, Paris

Asters and chrysanthemums are closely related, and Monet loved to plant both these flowers in his garden for a final flourish at the end of the growing season. Among the aster varieties he admired are the New England hybrids, developed from species native to the meadows and way-sides of North America. These were mostly tall varieties that made good backgrounds for the lower-growing cushion chrysanthemums that have been developed from species native to Asia.

Monet undoubtedly was influenced to grow chrysanthemums not only from Japanese wood-block prints he owned, many of which featured chrysanthemums, but also because his friend Gustave Caillebotte had a passion for them.

There are many kinds of chrysanthemums, from dwarf to tall, in a wide range of flower forms, from single to double. The largest are called football mums because their flower heads are large and rounded. However, there are varieties that have spoon-shaped and spider-shaped petals among other variations. The color range is vast, though mostly in warm colors, including yellow, orange, bronze, pink, purple, and many shades of red, as well as white.

The Japanese-like simplicity of this chrysanthemum arrangement contrasts well with the French wallpaper design in the background, with its delicate nosegays of spring flowers. The warm, rustic colors of the container—probably a knitted sleeve covering a clay pot—suggest autumn, the season with which the chrysanthemum is most closely identified.

The
Arrangements
111

onet liked to grow many flowers in pots, and his painting of chrysanthemums appears as though the plant is growing in a pot that has been covered with a knitted sleeve for decorative effect. We have, therefore, used potted plants rather than cut flowers to create a seasonal grouping around a flight of steps at our home. A similar grouping can be created on a deck, terrace, patio, or even in a window box. The beauty of chrysanthemums is that inexpensive potted plants in a ready-to-bloom stage are widely available from local garden centers, especially in late summer and early autumn. Winter-blooming pansies and some potted coleus (both available in late summer and autumn) make the display more pleasantly complex.

Making the Arrangement

1. Position the urns on either side of the stairs, then fill them with pansies and chrysanthemums, positioning the chrysanthemums in the middle and the pansies around the edge, or planting them in separate urns.
2. Transplant coleus into two of the clay pots, and fill the rest of the pots with chrysanthemums. Place these in groups up the stairs and on the flat areas of the stair rails. Chrysanthemums and pansies will tolerate mild frosts. If you choose hardy varieties of chrysanthemums, transfer them to the garden after the display loses its color. There they will overwinter and bloom the following season.

Overall Dimensions
4' by 4' area

Materials
- 2 low urns
- 2 pedestal urns
- 10 clay pots in various sizes
- 15 to 18 potted chrysanthemums in various colors (avoid white to make the display more autumnal)
- 5 bright red coleus
- 2 to 4 large potted winter-blooming pansies

Conditioning
Flowers can be purchased in plastic pots and transplanted into more decorative containers. Usually these plants will need watering daily to keep them healthy; add liquid fertilizer to the water once a week. As flowers fade remove them by pinching, encouraging more flower buds to open.

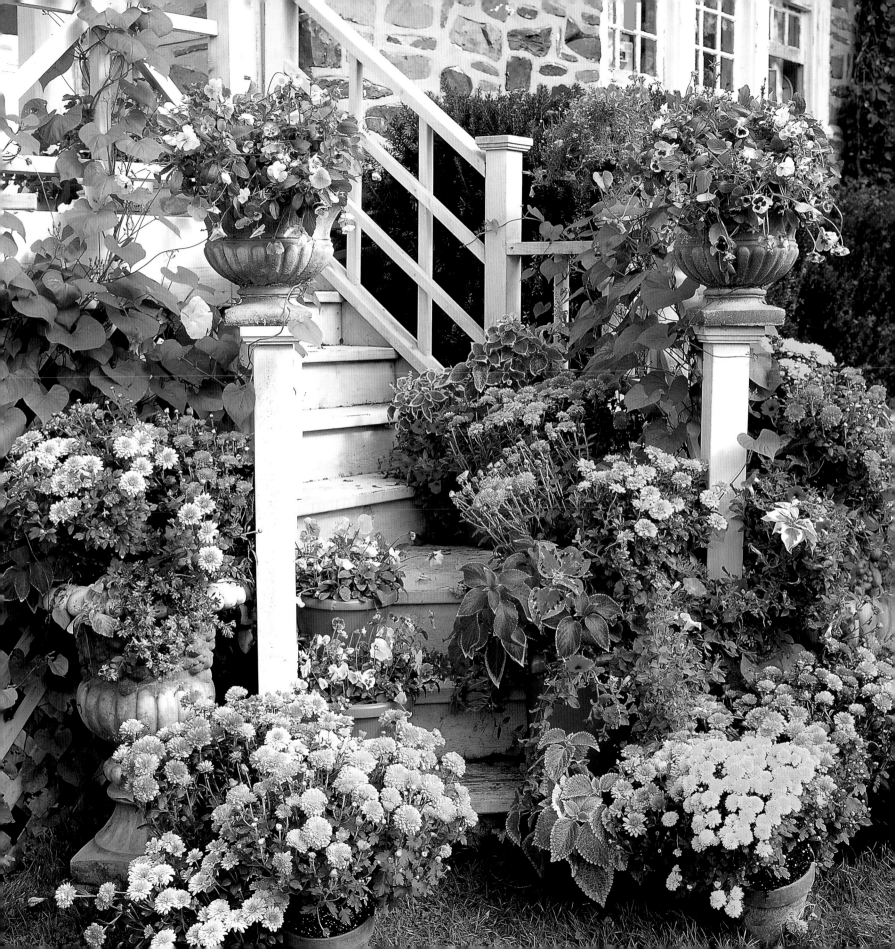

Still Life: Hydrangeas

Anne M. Bremer

Oil on canvas; 1915; Barrett H. Courtesy of Westphal Publishing, Irvine, California

Hydrangeas are as synonymous with France as goat cheese and fine wine, and grow especially well in coastal locations. Anne Bremer, a member of the school of Impressionists known as the Plein Air Painters of California, painted a stunning arrangement of white, pink, and blue hydrangeas in a blue vase, though the pink pigments have faded somewhat over the years. The color range of hydrangeas is similar to that of lilacs, and the flower form is also similar, except the florets of hydrangeas are larger, as are the flower clusters. Blooming from early summer to autumn frost, the ball-shaped flowers are distinctive in floral bouquets, with papery four-petaled florets and a color range from white through all shades of pink and red to the deepest blues and violets. Green, bronze, and parchment colors are also evident as the flowers age on the plant. These summery flowers are perfect for massing in a vase by themselves, especially when they are allowed to cascade in all directions.

In the garden, the hydrangea is one of the most dramatic summer-flowering shrubs. Since soil pH affects the flower colors (acidity promotes pink blooms, while alkalinity promotes blue), it's sometimes possible to have several colors—ranging from pink to blue—all open at one time on the same plant. Though hydrangeas are considered hardy, in northern gardens the tops may die down after frost, and new growth emerges from the roots. In mild winter areas—such as coastal California and the Gulf states—hydrangeas will reach much larger proportions.

The delicate clusters of flowers in clear pastel shades require little adornment. A pretty bowl, and perhaps a few airy white flowers, are all the additional embellishment these summery blooms need.

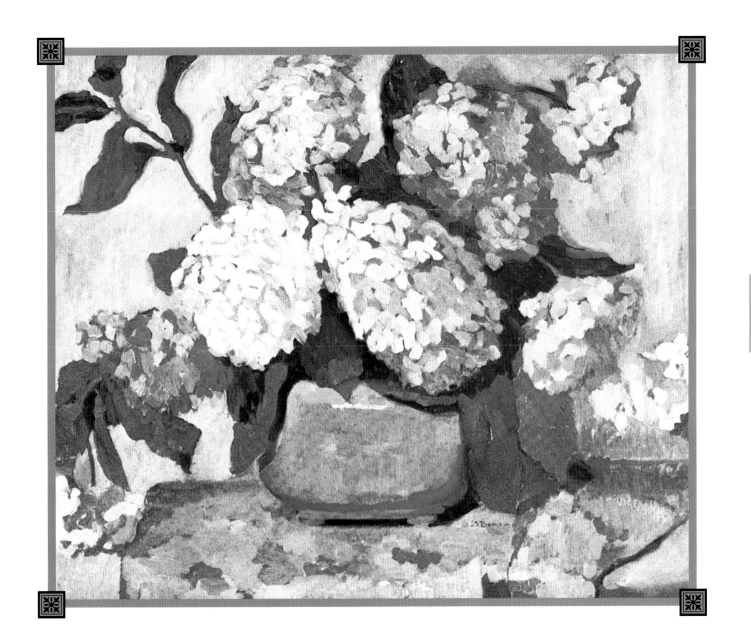

We have used large pink and bright blue hydrangeas to replicate the arrangement featured in Bremer's painting, but have added some white double-file viburnums to represent the smaller, slightly green flowers seen in the painting. This subtle change in flower size is vital and allows space between the flowers to become part of the design. The stone wall background is part of the kitchen in our two-hundred-year-old farmhouse.

Making the Arrangement

1. Fill the container three-quarters full of tepid water and add floral preservative.

2. Assemble the flowers to be used in the arrangement. Crumple the chicken wire into a ball and place it into the container, making sure that it fits snugly around the sides.

3. Begin arranging with the main material by placing a pink hydrangea in the center of the container, positioning it securely in the chicken wire. This first flower will establish the height of the arrangement, which should be approximately one and a half times the height of the container.

4. Add the remaining pink and blue hydrangeas, alternating the colors to build the arrangement into a relaxed dome shape.

5. Tuck the white viburnums in among the hydrangeas so that each branch extends beyond the rounded heads of the hydrangea flowers.

6. For a still life effect, place the arrangement on a window with a deep sill or on a tablecloth with a design and a color tone that echo the flowers in the arrangement. Top off the container with water as needed.

Overall Dimensions
18" tall, 15" wide

Materials
- Soup tureen or container with large opening and squat body in a bright pastel tone. (Note: Avoid using white, gray, or clear glass, which would detract from the flowers, or black, which would tend to deaden them.)
- Floral preservative
- 12" square piece chicken wire

MAIN MATERIAL
- 5 large-headed bright pink hydrangeas (such as 'Forever Pink'), 18" stems
- 2 pale blue hydrangeas (such as 'Nikko Blue'), 15" to 18" stems

FILL MATERIAL
- 2 or 3 white double-file viburnums (*Viburnum tomentosum* 'Mount Shasta'), 18" stems

Conditioning
Gather flowers when color is at its peak. Remove leaves from the bottom two-thirds of each stem. Cut each stem at an angle and place in a bucket of warm water with flower preservative. Place in a cool area for 24 hours.

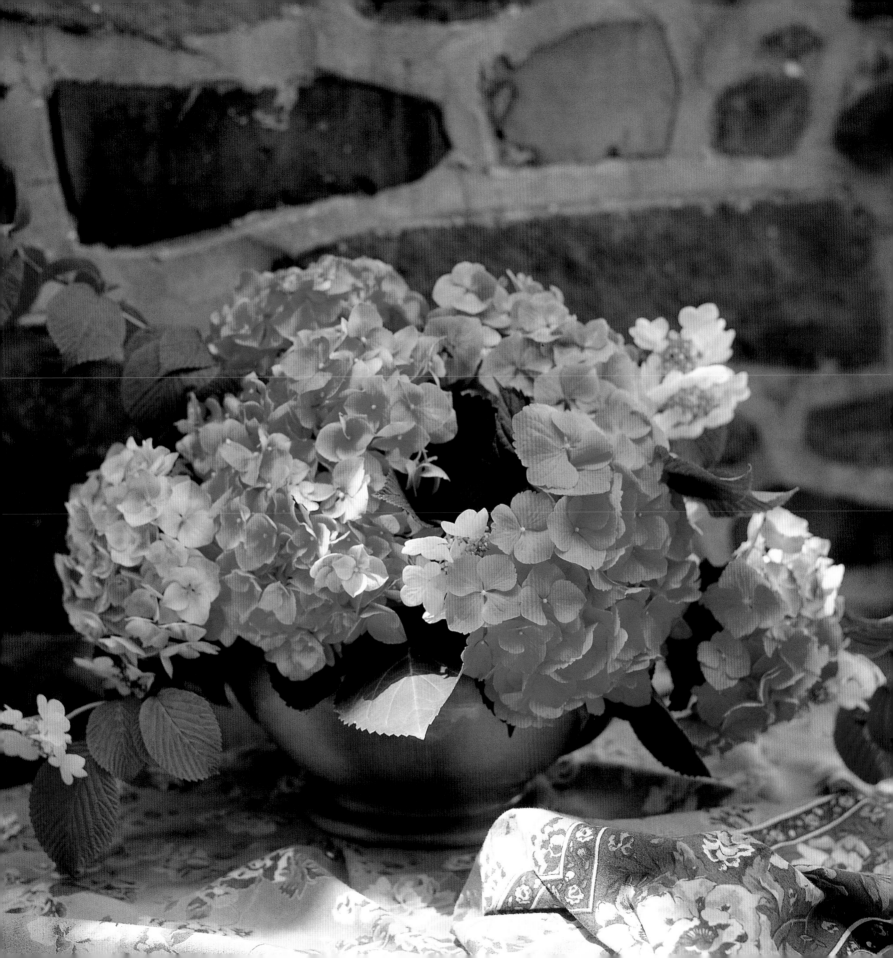

Improvisation

Childe Hassam

Oil on canvas; 1899; National Museum of American Art, Washington D.C.

This is among our favorite Impressionist paintings. *Improvisation*, one of Childe Hassam's most romantic works, was painted on Appledore Island, off the coast of Maine. The work shows a young woman, surrounded by floral arrangements, who is playing a piano in Celia Thaxter's parlor. The improvisation in the title of this painting undoubtedly refers to the music being played on the piano. What is especially appealing about the room is the flower arrangements, which partner hardy water lilies held aloft in tall, fluted glass vases with long-stemmed poppies.

The water lily is rarely used in floral arrangements (though Monet made an industry out of painting them floating on the surface of his pond). Its flower stem is weak when removed from its submerged root, and the only practical way to keep the flower fresh indoors is to cut the stem close to the flower head and float the flower in a shallow dish of water—perfect for a dining room centerpiece—or to use it held high in a tall glass vase with a flared mouth, as seen here.

Celia Thaxter had a small pool (actually a reservoir) at the back of her cottage, and hardy water lilies grew well there in summer—until muskrats invaded the island and ate them all. Water lilies are easy to grow, provided their roots are permanently covered with water and their circular leaves can float on the surface. There are miniature varieties that can be grown in tubs filled with water, such as whiskey half-barrels. Hardies can survive freezing winters provided the roots remain below the ice line. Tropicals are larger-flowered and include blue in their color range; paradoxically they bloom for several weeks longer than hardy water lilies, but they come under stress when the water temperature drops below 60°F (16°C), and so in northern climates they need to be held indoors in a holding tank to overwinter.

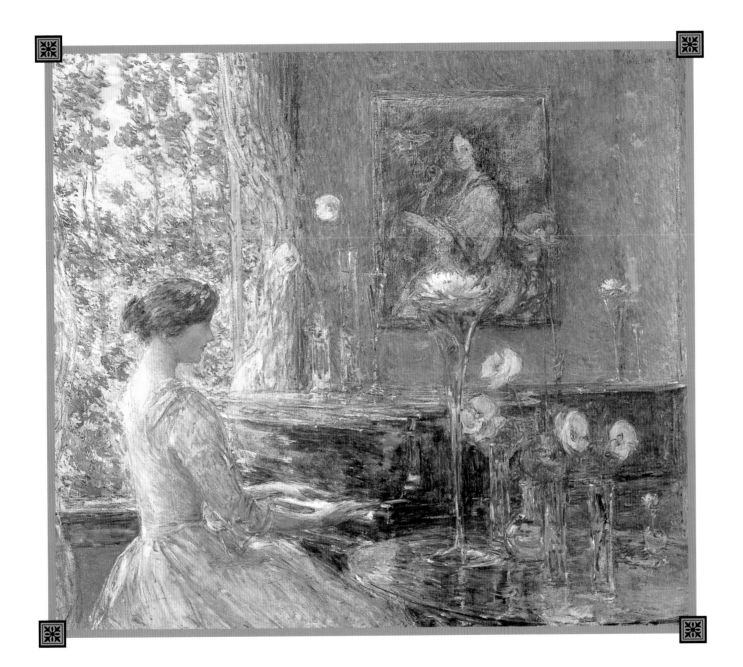

A top a slender, fluted glass vase, the water lily is an elegant flower, offering in its simplicity a sophistication not easily improved upon. In our arrangement we have chosen to use several styles of vases to make an attractive grouping for two colors of water lilies—white and yellow.

Because the flowers of water lilies are sensitive to wilting, they must be cut underwater to keep air from entering the stem. Although they are beautiful when arranged, do not expect more than a day or two of vase life. Also, water lilies are light-sensitive and will remain open only during sunlight hours; they'll close up on cloudy days and at night.

Making the Arrangement

1. Determine the location for the vases, avoiding places where elbows or coattails can knock the vases over.

2. Fill the vases with tepid water to about 1" (3cm) from the top.

3. Carefully balance each flower atop the vases so that the outer petals rest against the lip for support.

4. Place poppies with long stems in tall, cylindrical glass containers and arrange in the background.

Overall Dimensions
14" tall, 4" wide

Materials
- 12 glass containers of different heights
- 1 yellow water lily, 4" stem
- 1 white water lily, 4" stem
- 10 pale pink poppies (3 with 8" stems; 7 with 3" stems)

Conditioning
Cut each water lily stem underwater immediately before placing the flower into the arrangement. Do not hold the water lilies overnight, but use them immediately upon cutting. Place poppies in very hot water immediately upon cutting. Place poppies in a cool area for 24 hours before arranging.

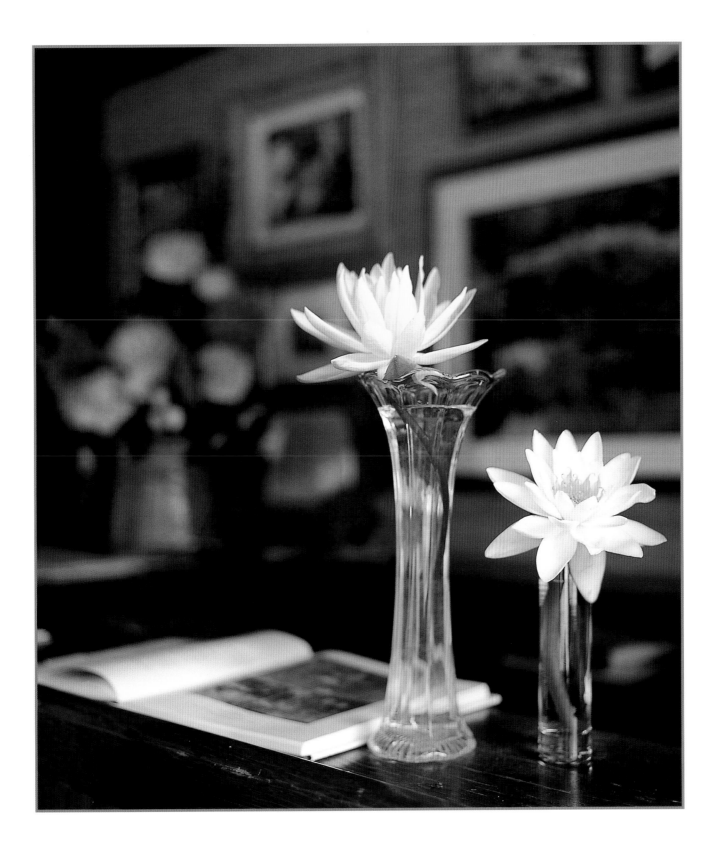

Vase of Gladiolus

Pierre-Auguste Renoir

Oil on canvas; 1881; Musée d'Orsay, Paris

The Impressionists greatly admired gladiolus, a tender, summer-flowering bulb, for its vibrant color range, spirelike habit, and the exotic petal formation of its florets. When Renoir lived near Nice, his seven-acre property afforded him plenty of space to grow the large-flowered florist-type gladiolus, which could overwinter in the nearly frost-free climate of his garden. In fact, his gardeners had permission to sell excess blooms in local markets as a source of income. Indeed, after roses, Renoir's favorite flower to paint as a still life seems to have been the gladiolus.

It is interesting to note that the gladiolus Monet grew were significantly different from those grown by Renoir. Monet's gladiolus appear to be a special hardy variety with smaller blooms and a spikier habit; these were capable of overwintering in his Normandy garden. In Normandy, the giant florist's gladiolus grown by Renoir would need to be lifted from the soil at the end of each growing season and stored indoors in a cool, frost-free place for replanting the following spring.

The color range of gladiolus is extensive. It includes not only red, pink, orange, yellow, white, and blue but also green and maroon, as well as beautiful bicolors. If the planting of gladiolus is staggered, then a succession of bloom is possible from midsummer until autumn frost; gladiolus are so popular as cut flowers, however, that they are available even through the winter months from greenhouse growers.

The arrangement in Renoir's painting is a polychromatic selection of bold colors that might benefit from a few apples, peaches, or fallen petals around its base to soften the rather austere surroundings. This painting was accepted as a fee by the family doctor for the safe delivery of Renoir's first son, Pierre.

*B*ecause of their tall, stiff, spiky flower form, it is difficult for gladiolus to be versatile in an arrangement. Generally they are displayed alone, simply fanned out in a tall vase that accommodates the long stems, but they are much more beautiful when combined with other less rigid floral elements. For this design we selected a tall, sleek Italian crystal vase as the container, and added grasses, fluffy pink Joe-Pye weed, fragrant white hostas, and powdery blue Russian sage as background fill, plus some Oriental lilies as a foreground accent. At Cedaridge Farm we are so fond of arranging gladiolus and Oriental lilies together that we grow them in the same bed, and create arrangements for the high-ceilinged conservatory that serves as a breakfast room.

Making the Arrangement

1. Begin the arrangement with the gladiolus, first adding the stems at a slight angle at the edge of the container and working toward the center.

2. Next add the fill material—the grass, Joe-Pye weed, and Russian sage—spacing it throughout the design and allowing some to fall freely around the edge of the container.

3. Move the arrangement into its final location and top up the container with warm water. Adding a few extra flowers at the base of the vase adds a softening effect to the design.

Overall Dimensions
40" tall, 30" wide

Materials
• 1 tall crystal vase, 24"

MAIN MATERIAL
• 10 to 12 full-flowered gladiolus in various colors, 24" to 30" stems

FILL MATERIAL
• 3 to 5 stems of maiden grass (*Miscanthus* spp.), 40" stems
• 2 to 3 stems of Joe-Pye weed, 30" stems
• 5 to 7 stems of Russian sage, 24" to 30" stems
• 3 to 4 stems of white 'Honey Bells' or 'Royal Standard' hostas

ACCENT MATERIAL
• 2 to 3 stems of 'Casablanca' Oriental lilies
• 1 stem of 'Stargazer' Oriental lily

Conditioning
Gladiolus should be cut when the lower florets have started to open and the upper florets are in mature bud. Place the flowers in a few inches of warm water in a cool location for at least 24 hours before arranging. If purchased from the florist check that only a few flowers on lower stems are open. Once home, re-cut the stems and place in warm water up to the bottom floret. Place in a moderately warm area until more flower buds open.

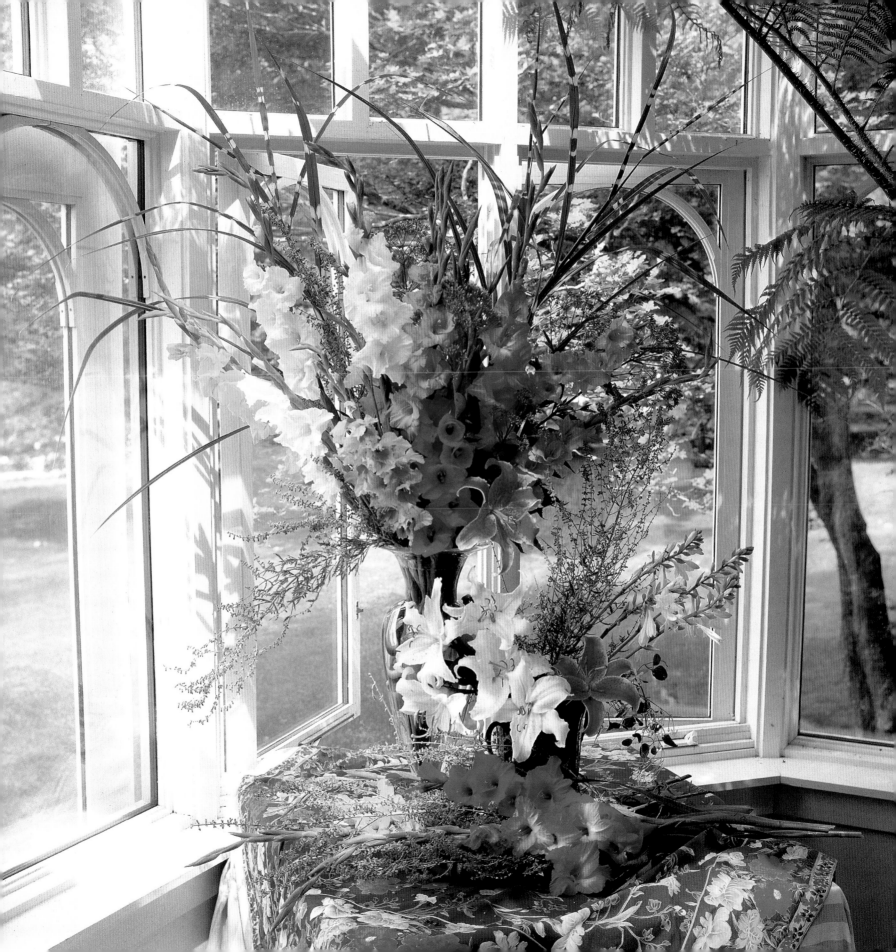

Following in the Footsteps of the Impressionists

For a stimulating cultural adventure, it's hard to beat a visit to some of the places associated with the great Impressionist painters—not only the major museums that display their art but where they chose to live and paint. Many of the gardens and museums have limited hours, so make sure to call before you visit.

UNITED STATES
Gardens

Celia Thaxter's Garden
Appledore Island
Isles of Shoals, ME
(607) 255-3717 (Shoals Marine Laboratory)
Visits by appointment only.

Cedaridge Farm
Box 1
Gardenville, PA 18926
(215) 766-0699
Visits by appointment only.

Museums

The Barnes Foundation
300 North Latch's Lane
Merion Station, PA 19066
(215) 667-0290
Visits by appointment only.

The Metropolitan Museum of Art
1000 Fifth Avenue
New York, New York 10028-0198
(212) 879-5500

Philadelphia Museum of Art
Philadelphia, PA 19101
(215) 763-8100

National Gallery of Art
4th Street and Constitution Ave.
Washington, D.C.
(202) 357-2247

EUROPE
Gardens and Walks

Caillebotte's Garden
6 rue de Coney, 91330 Yerres
France

Cézanne's Garden
Avenue Paul Cézanne
13090 Aix-en-Provence
France

Monet's Garden
Rue Claude Monet
27620 Giverny
France

Renoir's Garden
Chemin des Collettes
06800 Cagnes-sur-Mer
France

Van Gogh's Walk, Auvers-sur-Oise
Tourist office, at Manoir des Colombiers
France
Provides a map of sites.

Van Gogh's Walk, Saint-Remy
Office of tourism, at Place Jaures
13210 Saint-Remy-aux-Provence
France
Provides a map of sites.

Museums

Van Gogh Museum
7 Paulus Potterstraat
Amsterdam
Holland

Kroller-Muller Museum
De Hoge Veluwe National Park
Otterlo
Holland

Musee Marmottan
2 rue Louis Boilly
75016 Paris
France

Musee d'Orsay
62 rue de Lille
75007 Paris
France

Sources

Here is a list of sources for some of the most important plants used by the Impressionist painters in their arrangements.

Hydrangeas
Hydrangeas Plus
Box 345
Aurora, OR 97002

Peonies
Gilbert H. Wild & Son
Box 338
Sarcoxie, MO 64862

Roses
Heirloom Old Garden Roses
24062 NE Riverside Drive
St. Paul, OR 97137

Irises, Bearded
Cooley's Gardens
11553 Silverton Road NE
Silverton, OR 97381

Poppies
Thompson & Morgan
Box 1308
Jackson, NJ 08527

Sunflowers
W. Atlee Burpee Co.
200 Park Avenue
Warminster, PA 18974

Lilies, Garden
B & D Lilies
Box 2007
Port Townsend, WA 98368

Primroses
Barnhaven Primroses
Langerhouad
22420 Plouzeambre
France

Tulips, Heirloom Varieties
Old House Gardens
536 Third Street
Ann Arbor, MI 48103

Metric Conversions for Measurements

Note that measurement conversions are approximate.

IMPERIAL	METRIC	IMPERIAL	METRIC
		15 inches	38cm
		18 inches	45cm
		20 inches	51cm
¼ inch	0.6cm	24 inches	60cm
½ inch	1cm	30 inches	75cm
¾ inch	2cm	36 inches	90cm
1 inch	2.5cm	1 foot	30cm
2 inches	5cm	1½ feet	45cm
3 inches	7cm	2 feet	60 cm
4 inches	10cm	2½ feet	75cm
5 inches	12cm	3 feet	90cm (1m)
6 inches	15cm	4 feet	1.2m
7 inches	18cm	5 feet	1.5m
8 inches	20cm	6 feet	1.8m
9 inches	23cm	8 feet	2.4m
10 inches	25cm	10 feet	3m
12 inches	30cm	12 feet	3.5m

Index

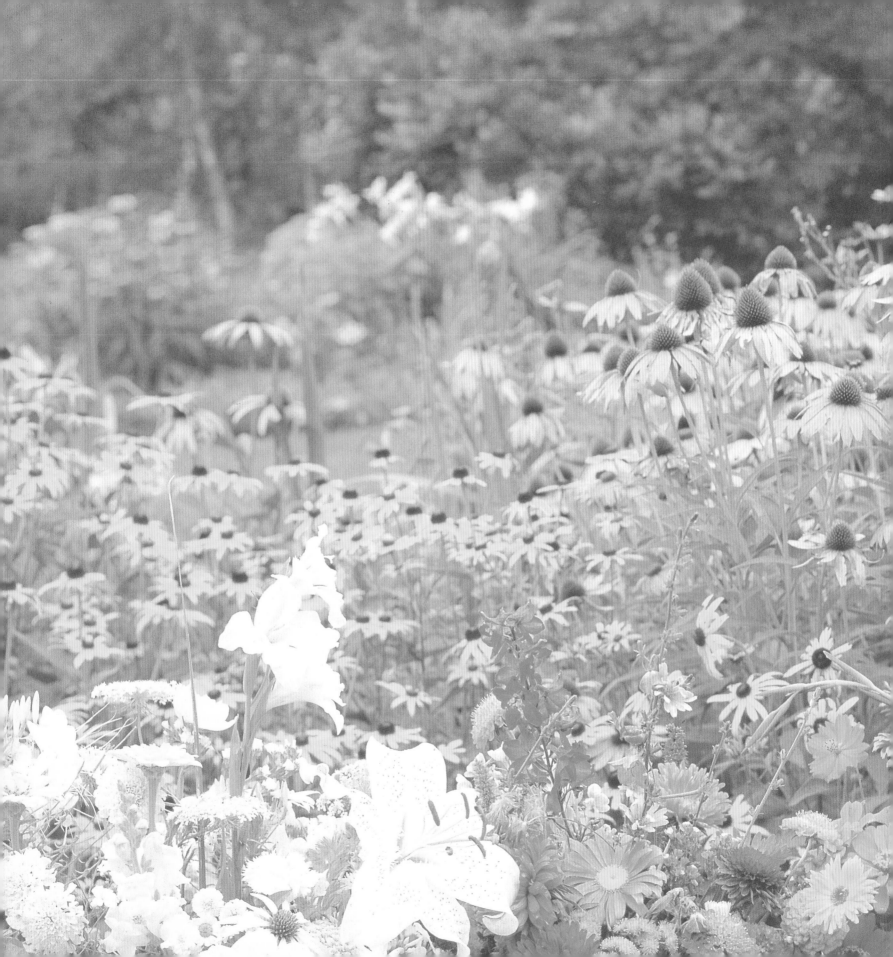